This project was made possible through the generous support of Macy's and Nikon.

*And in addition, the assistance of **Latina** magazine and InnerWorkings, as well as our advisors, the Mexican Tequila Regulatory Council, the Cultural Institute of México, Washington, D.C., and the Cultural Institute of México, New York.*

All publishing profits from this book benefit the Mexican American Legal Defense and Educational Fund

UADALAJARA LIBRE →

← TEPIC LIBRE

← TEQUILA

HEAVEN, EARTH, TEQUILA

Un Viaje al Corazón de México

Photographs by

Douglas Menuez

Introduction by Victor E. Villaseñor

Art Direction by Andrés Zamudio

Editorial and Design Direction by Thomas K. Walker

Text by Douglas Menuez with Andrés Zamudio

Waterside Publishing, Inc.

Waterside Publishing, Inc.
www.waterside.com

Heaven, Earth, Tequila: Un Viaje al Corazón de México
Copyright © 2005 by Douglas Menuez.

First Edition

Library of Congress Control Number: 2005925616
ISBN 0-9766801-0-6

10 9 8 7 6 5 4 3 2 1

Agave: An indigenous American plant that is part of the lily (amaryllis) family and is sometimes known as cabuya, mezcal maguey, mexic, pita, and teometl.

Blue Agave: Amaryllidaceous agave tequilana *is one of 136 species of the agave, or maguey ("mah-gay"), that grows in Mexico. The heart of the blue agave, or* piña *root, grows from the darkness of the earth toward the sky; it can weigh from 80 to 300 pounds and grow up to 15 feet tall. The piña is roasted, fermented, and distilled to make tequila.*

Mayahuel: Aztec goddess of the maguey, and by extension, alcohol. From her remains came the first maguey plant, yielding pulque, *the ritual elixir and ceremonial offering to the gods. Observing a drunken mouse, she discovered it had become inebriated drinking the fermented juice of the agave. She is credited with bringing this knowledge to humans.*

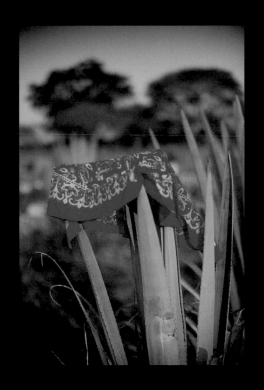

*"We are the children of Quetzalcoatl,
the Plumed Serpent. He is our creator."*

Author's Note

WHILE READING SALMAN RUSHDIE'S THE GROUND BENEATH HER FEET, I WAS struck by a scene in which an Indian rock singer visits a distillery in the Mexican town of Tequila, where she sees naked men in vats of agave juice making tequila. First, I thought the image too precise and unusual to be completely fictional, and imagined that Mr. Rushdie must have observed this himself. Second, who knew there was an actual town named Tequila? Intrigued, I asked my friend Andrés Zamudio, a Mexican art director living and working in New York City, what he knew. We met at a bar in SoHo, and over a bottle of good tequila I listened intently as he spoke about its meaning in Mexican culture. "To understand Mexico, you must understand something of tequila and tradition," he said. "Tequila was a gift from the gods to the Aztec, a sacrament to be respected, which it remains today. Yes, we know how to enjoy ourselves, but it's much deeper than that," he explained. He related stories of his family and friends on their ranch in Northern Mexico, and how important this ancient liquor was to them and to all Mexicans. "Tequila is Mexico," he stated simply. He had not, however heard of a technique for making tequila involving naked men in vats, and was skeptical. Over our last shot, we resolved to find out if such a technique existed, and, if so, where such a distillery could be found. We both felt that whatever we found would be well worth learning about and photographing.

Six months of research later, we confirmed the story and found a distillery in Jalisco state that still used this traditional technique. This was very exciting news, as we knew a door had opened on an adventure. We headed to the town of Tequila, with a loose plan to shoot the land, the hacienda, and everyday life of the people we met, sampling the purest blue agave tequila along the way. We hoped to capture a sense of place and something of the history of tequila and of Mexico. We did not realize how a simple quest would lead to a journey of discovery, or more precisely, rediscovery. I thought I knew Mexico—I've traveled and photographed there for over twenty years, and Andrés was born and raised in Durango—but after learning just a little about tequila, we quickly understood that neither of us actually knew much about the extremely complex history and mestizo culture of Mexico. Tequila opened our hearts to another Mexico, an enduring, ancient place, where, 500 years after the European conquest, the spirit, pride, and passion of the people continue undiminished. A land where, despite all the contradictions and struggles for political and economic justice, anything is possible. What follows here is taken from journal entries I wrote in Tequila and Guadalajara between October 21, 2000 and December 6, 2004. The details are accurate in spirit if not perfectly accurate, as we tasted much of what the gods left the Aztecs.

Introduction

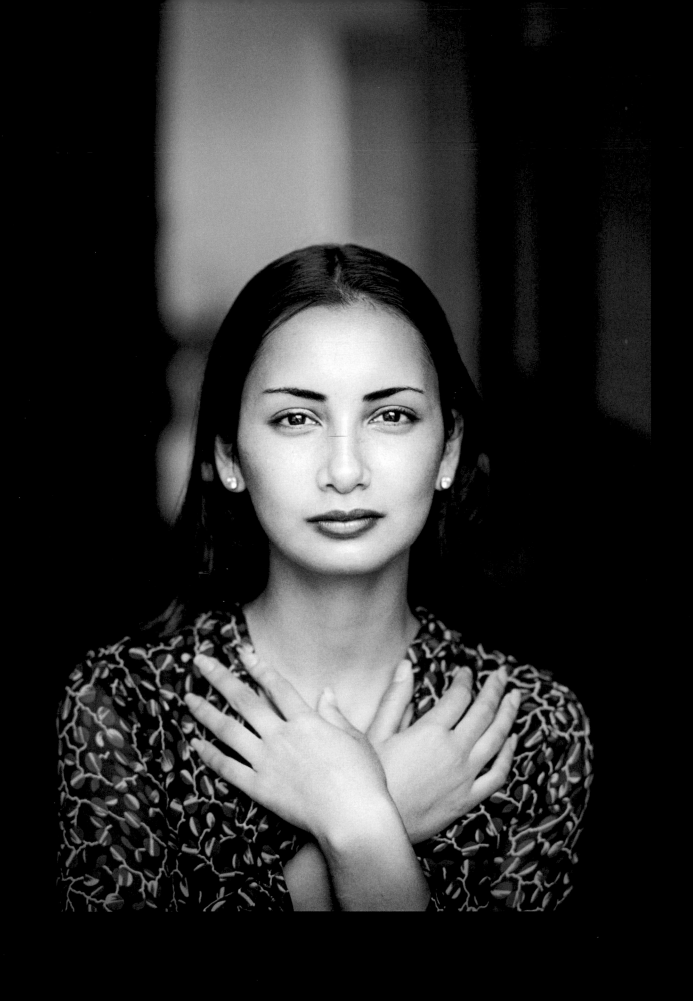

MEXICO! MEXICO! *MEJICO!* THE LAND OF MY FATHER AND MOTHER! The land of *el mestizo*–the blending of European and indigenous bloods. The land of a thousand stories, and some of them so huge and wild and incredible that they rival the Bible for power and the ingenuity of humankind.

For instance, I was just a little kid growing up in the Oceanside-Carlsbad area of San Diego County, California, when my father—an ex-bootlegger—explained to me that the only reason we lost the Garden of Eden was because there was no tequila.

"Listen to me closely," he said to me, "if I'd been the local bootlegger back in the Garden, I would've sold a bottle of tequila to Adam. Good tequila. The best. From Los Altos de Jalisco. And Adam would've had a couple of good big shots, then when God came down and asked him who did it, Adam would've pushed back the rim of his hat and told God straight in the face, 'I did! So what? *Yo lo ise, y que?*' God would've been taken aback. He would've looked at Adam more closely, and He would've seen that Adam was willing to defend his bride, his woman, at all cost. This would've moved God's heart, so He would've said, 'What are you drinking, Adam?' And Adam would've said, 'Tequila!' And God would've said, 'Let me try some,' and God would've loved it, and we'd all still be in the Garden drinking tequila with God and feeling pretty damn good!

"You see, *mijito,* tequila is the only thing that is missing from us bringing Heaven down here to Earth, uniting us with the Almighty once again. God doesn't like crybabies. God likes men who are men, and willing to defend their loved ones with both of their *tanates* in hand. This is the spirit *de Mejico!* This land that used to be the passageway from South America to North America for tens of thousands of years before the Europeans ever came. That's why my mother from Oaxaca, God bless her soul, explained to me that parrot feathers from South America can still be found as far north as Canada, taken there by traveling wise men and women."

Then my dad would tell me other stories about Mexico and how his aging mother had always poured a little bit of tequila into her coffee to sip while she sat in the outhouse praying to God at sunrise with her Bible and rosary. I was twelve years old when our father finally took our whole family to his homeland of Los Altos de

alisco. We visited the town of Tequila and saw how the tequila was made. We traveled to my dad's village of Arandas and we walked through the fields of the agave plants, the blue-gray cactus-like plant that the tequila is made from by cutting away the leaves and boiling the heart, producing a thick, honey-like syrup with a deep, earth-like smell and taste. He pointed to a hillside just east of town and told us how his father, a tall handsome redheaded Spaniard, had once fought with a serpent that stood eight feet tall on this very hillside.

"He'd been drinking tequila for days and was feeling pretty damn glorious when he saw the great snake come charging at him," said our dad. " 'What have You done God?' he shouted to the Heavens. 'Have You sent the Devil himself down to Earth to test me?' And being a good Christian, he instantly accepted God's challenge, as all us mortals got to do when life gives us a treacherous twist, and he whirled his frightened horse about in a spin, confusing the terror-stricken animal. Then he ripped a dead limb off a tree and bolted forward *con un grito de gusto*, ramming the limb into the monster's mouth. Then he roped the thrashing serpent, dragged him into town and some strong woodcutters chopped off his head.

"I was there, a little kid, and we saw the Heavens open up," said our dad, "and we all felt the Holy Hand of God come down and give us peace. Because that serpent had held us in evil hostage for years, devouring innumerable little pigs and goats and several children. The priest came and gave us his blessing. Two barrels of the finest tequila were served by our local distillery, and people prayed and sang and danced and made love for days! This is *Mejico*, where God's Garden still lives! A land where the Holy Hand of God is only one barrel of tequila away, and prayer and dancing and singing are all wrapped together for the Great Glory of the Almighty!"

And it must be true. How else can you explain how tequila, a liquor that was hardly known twenty years ago outside of Mexico and was considered a cheap, inferior drink, has now risen to such heights of popularity? Most liquor stores in the United States carry five or six different tequilas, from not-too-expensive to one of the most expensive bottles in the whole place, equal in quality and price to the finest cognac

from France. And in the fancy, upscale modern grills from New York to Los Angeles a person might find as many as fifteen different tequilas or more. Just like salsa has been outselling ketchup for over seven years, tequila—good tequila—is becoming the drink of choice across the nation. My father was right! We lost the Garden because there was no tequila, and the time has come for us to return to the Garden with a couple of good stiff drinks and *un grito de gusto*—to the Heavens!

Enjoy! Life, *la vida*, was meant for celebration! For giving thanks to the Almighty with song and dance, and of course, with drinking and feasting, but always with the understanding that respect *al derecho ajeno hace la paz!* The respect of others' rights makes peace, as the great Benito Juarez said, the Abraham Lincoln of Mexico. God bless us all!

—*Victor E. Villaseñor*

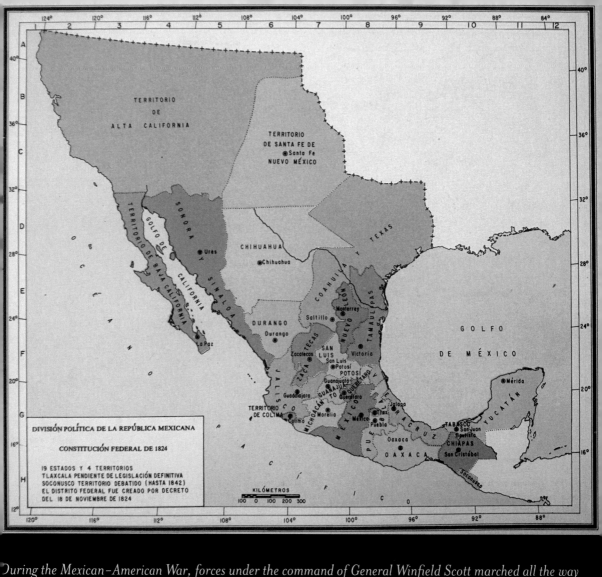

DIVISIÓN POLÍTICA DE LA REPÚBLICA MEXICANA

CONSTITUCIÓN FEDERAL DE 1824

19 ESTADOS Y 4 TERRITORIOS
TLAXCALA PENDIENTE DE LEGISLACIÓN DEFINITIVA
SOCONUSCO TERRITORIO DEBATIDO (HASTA 1842)
EL DISTRITO FEDERAL FUE CREADO POR DECRETO
DEL 18 DE NOVIEMBRE DE 1824

KILÓMETROS
100 0 100 200 300

During the Mexican–American War, forces under the command of General Winfield Scott marched all the way
to Mexico City, raising the American flag over El Zócalo, the main plaza, conquering and controlling the country.
In 1848, the price of peace, in addition to the previously taken state of Texas, included California, Nevada,
Arizona, Utah, New Mexico, and parts of Wyoming and Colorado. By the time of the Gasden Purchase of 1853,
the United States gained in total roughly half the land mass Mexico had inherited from Spain in 1821.

S PREADING OUT IN ALL DIRECTIONS BENEATH EL VOLCANO DE TEQUILA LIE THE VAST fields of agave plants, rising and falling from view as the truck bumps along the narrow road to the old town of Tequila. With the gathering dawn, men are revealed moving through the low fog in the distance, heading out to begin harvesting and tending the plants. For two hours the battered Chevy has pushed through the early morning darkness, up and down winding roads rising into the region many Mexicans believe is the heart of Mexico, Los Altos de Jalisco. It is here that tequila was born.

Looking across the spiky fields and down into fog-shrouded valleys below, the presence of the Mexicas, more commonly known as the Aztecs, can still be felt here. They cultivated the agave from which the powerful brew called *pulque* was created; the Aztecs and their ancestors drank pulque primarily for sacramental purposes for centuries before the Spaniards arrived. Aztec culture had at its core human sacrifice and warfare and was organized around strictly enforced rules, the beginnings of tradition in Mexico. For the Aztecs, one of those rules stated that anyone caught publicly drunk faced death, and another decreed that only the priests could have more than five glasses of pulque. There is evidence that agave has been cultivated in Mexico for more than 9,000 years and provided the first known alcohol of the Americas.

It was the Conquistadors in the 1500s who first made the local pulque into mezcal wine, later called tequila—in the town they founded and named Tequila at the foot of the volcano. There are various theories about the origins of the word tequila and how the spirit, town, and volcano all got named. It probably came from the Nahuatl language, spoken by the Aztecs and the tribe who lived here and grew the agave before the Aztecs dominated the region. The ground is littered with their black obsidian arrowheads and chips. According to one local legend, the Nahuatl word *tequitl* means "rock that cuts" and the men who made these arrowheads were called *tiquilos*.

The Nahuatl also worshiped the goddess Mayahuel, who represented agave. She had 400 breasts that oozed pulque. Not to be outdone, the Aztecs had 400 different gods for pulque. Today the Nahuatl language is still spoken by over one million people descended from the Aztecs.

Like champagne, tequila is tied to the region in which it is made. To be legally branded tequila, the product must be grown in Jalisco state or in the nearby states of Guanajuato, Tamaulipas, Michoacan, and Nayarit. Tequila must be fermented with at least fifty-one percent blue agave juice (*Agave tequilana Weber*) to pass official muster. A common misperception is that there is a worm in tequila but that is actually only done in some mezcals. Mezcal is legally produced from a different type of agave grown in the Oaxaca region to the South. Although pure blue agave tequila has recently gained an audience in the United States, most people outside Mexico are unaware of its history and nuances. Here in Mexico, tequila is a vital legacy of blood, pride, and tradition, equal to cognac to be slowly savored. Much like fine wine in France, tequila sits at the center of every traditional gathering, and in a way represents time—the time to sit and talk away the evening at the table with close friends and family, to enjoy and notice the moment. Many say it is the national drink and the only single thing made here that ties all Mexicans together in a shared history.

For the blissfully ignorant traveler, Mexico can seem a fulfillment of low expectations. They don't expect to see more than their preconceived ideas about Mexico, and they prefer to stay within their tourist bubble, detached from everyday life. Only after talking with locals and doing a bit of reading does a basic outline of the country's history come to light, revealing the deeper roots of the culture. An open-minded visitor will then find opportunities to partake of a rich experience.

The true story of Mexico is very subtle, a direct result of a singularly complex history made even more so by revisions of prior events by the victors of each era. Even the Aztecs, once settled in supreme power, destroyed their own nomadic history, choosing to adopt the gods and culture of the Toltec who came long before.

After Cortés defeated the Aztecs in 1521, the Conquistadors quickly established their rigid, top-down ruling structure, which combined the absolute authority of the Spanish crown and sword with the moral and social strictures of the Church. They wanted to obliviate Aztec history and they almost did, burying or destroying temples and palaces. And for 300 years after the conquest, New Spain served mainly to provide the mother country with precious resources, primarily silver

The Spaniards freely intermarried with the conquered and converted Indians, quickly creating the mestizo culture that remains today. The Spaniards were overthrown in the War of Independence of 1810–1821, known as El Grito. They were followed, however, by other nations seeking domination; the Americans, who in 1848 took a big chunk of old Mexico, which had included the previously liberated Texas, plus Nevada, Utah, Arizona, New Mexico, California, Wyoming, and part of Colorado—half the original territory of New Spain—and the French, who in 1862 installed the ill-fated Emperor Maximilian. The French were overthrown five years later, followed by various civil wars between Conservatives and Liberals until 1867. A period of peaceful dictatorship led by Porfirio Díaz lasted 34 years. This was followed by the bloody hell of the Mexican Revolution in 1910, with its visionary heroes including Madero, Villa, and Zapata, who promised the peasants land reform that came slowly if at all. What did come was entrenched single-party rule for seventy-one years until Vicente Fox was elected in 2000, bringing Mexico to the current state of attempted reform by the new government.

Against a backdrop of battling drug lords and constant unrest in Chiapas caused by indigenous rebel groups, Mexico is struggling and slowly changing for the better in many ways. Foreign investment has helped make the Mexican peso one of the world's strongest currencies. Fundamental, radical changes are taking place in the political system and economy. Yet even as things change, tequila remains. Through its turbulent and tragic history, Mexico is entwined with the history of the agave and of tequila. From colonial days through the revolution to today, tequila has been woven into the culture. A growing factor in the economy, and one of the largest-selling spirits in the world, tequila will always be a vital symbol of Mexico.

The Plates

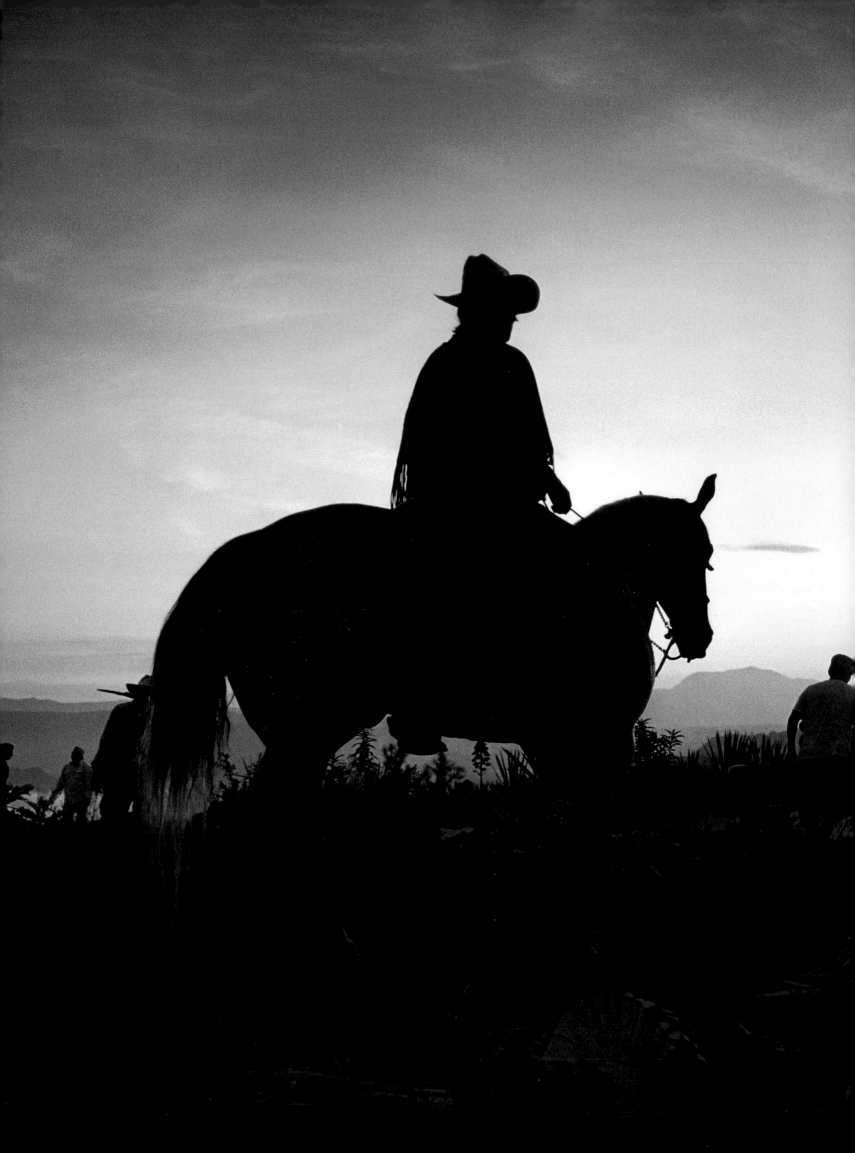

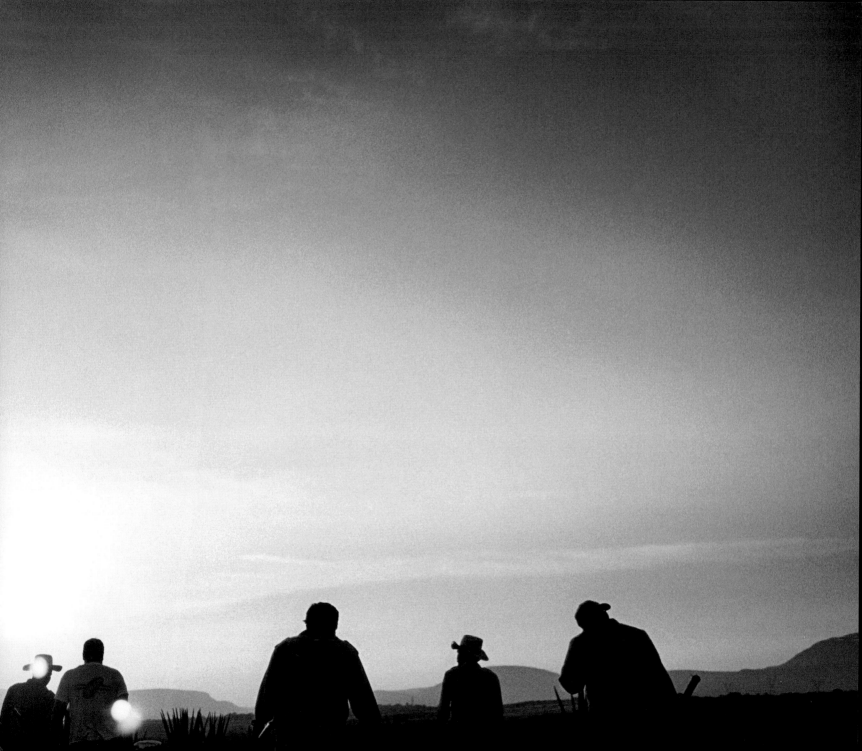

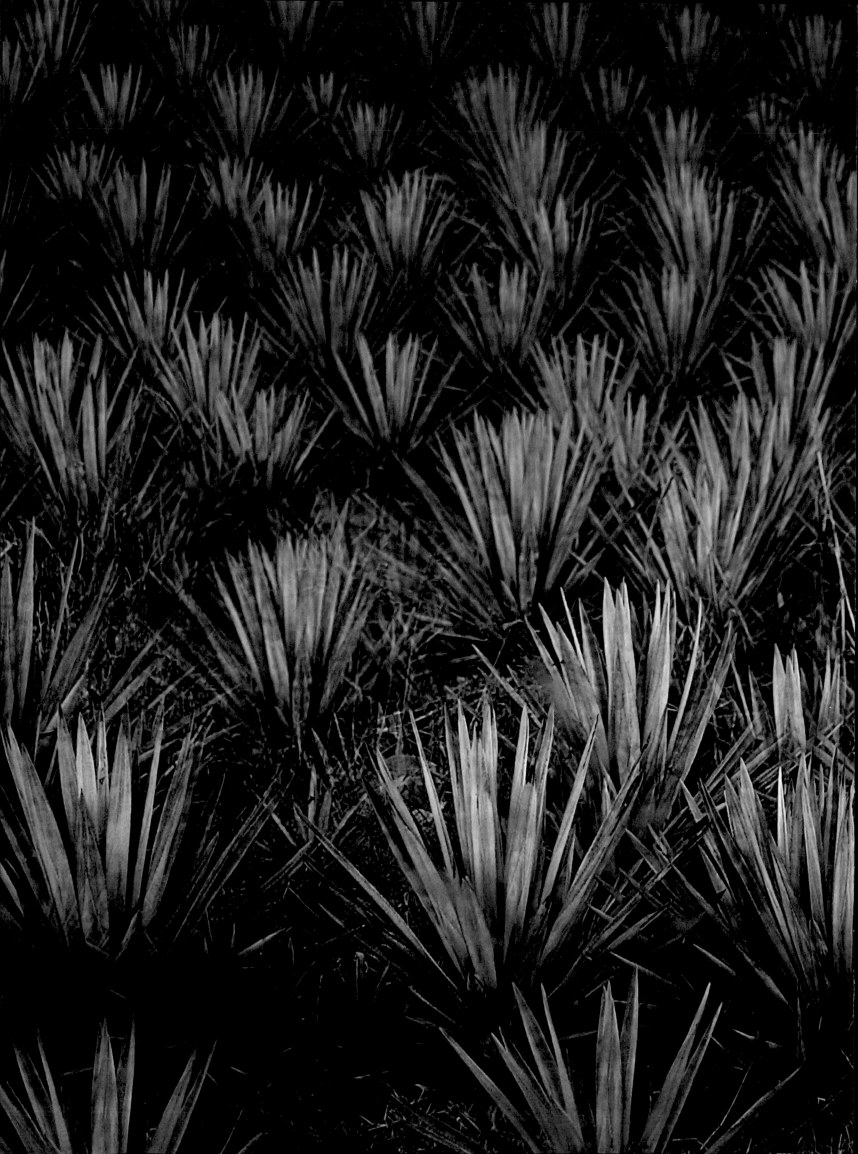

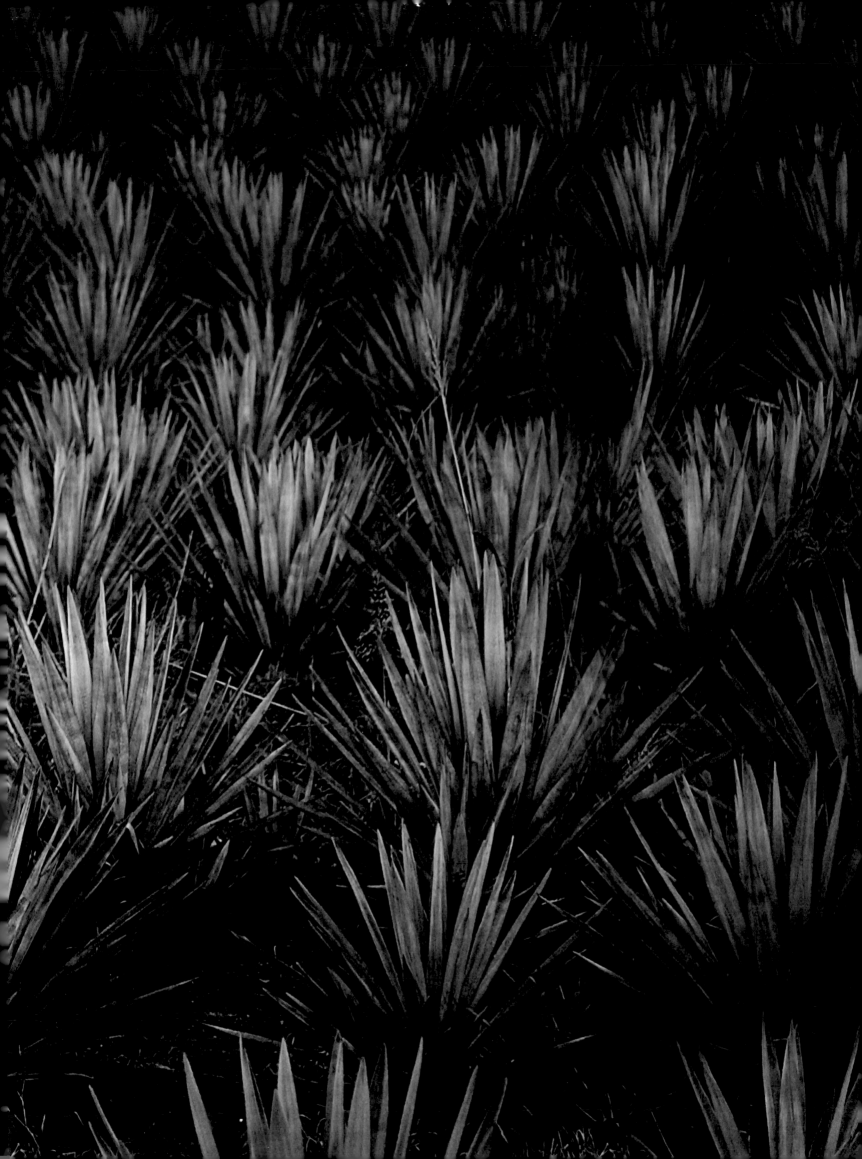

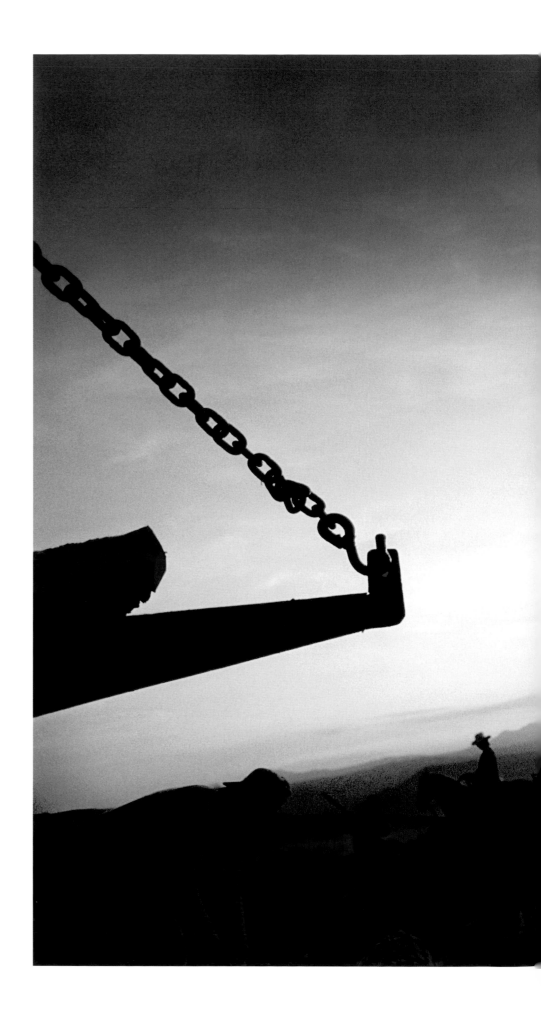

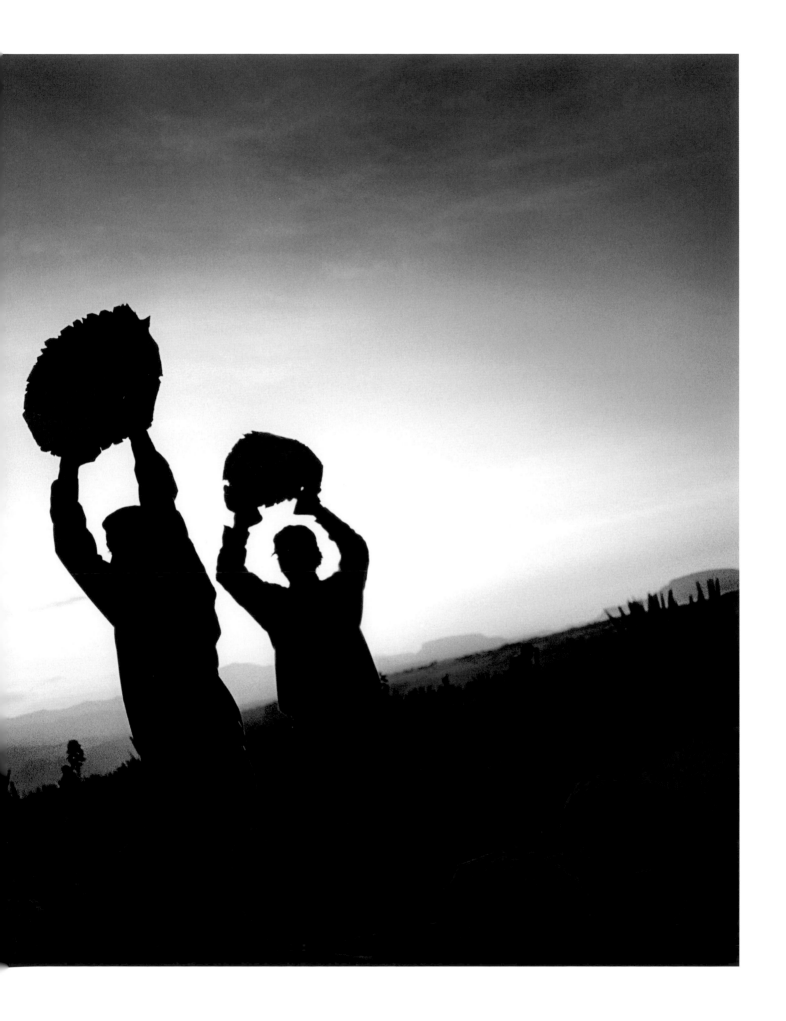

The truck jumps awkwardly off the highway into a field, running in between the tall rows of mature agave. The harvest is in full swing, with trucks and men spread across a wide swath. Now the sun is higher, turning the rich dark soil redder by the minute as it clears the ridgeline. These men work the fields 364 days a year. Their only holiday is El Dia de La Virgen de Zapopan, a religious festival and parade, which by chance is to be held on the following day in Guadalajara. All of the men working here plan to go. The first line of *jimadores* move down the rows, hacking off the sharp five-foot-tall leaves that make the agave look like a cactus, to reveal the sweet piña, the heart from which the sap is crushed. The men are called *jimadores* after the *cao de jima*, the long-handled, sharp-edged tool they use. Other men stoop and pick up the piñas, tossing them overhead from man to man. The piñas bounce along like punk rockers atop a mosh pit until they finally hurtle into the back of a waiting truck. The heat of the day is fast rising and the men stop to make fires of the cut agave spikes and cook rough breakfasts of tortillas, chicken, cheese, and beans. They swig campo coffee from canteens and quietly eat the delicious meal, licking greasy fingers for the last drops of salsa.

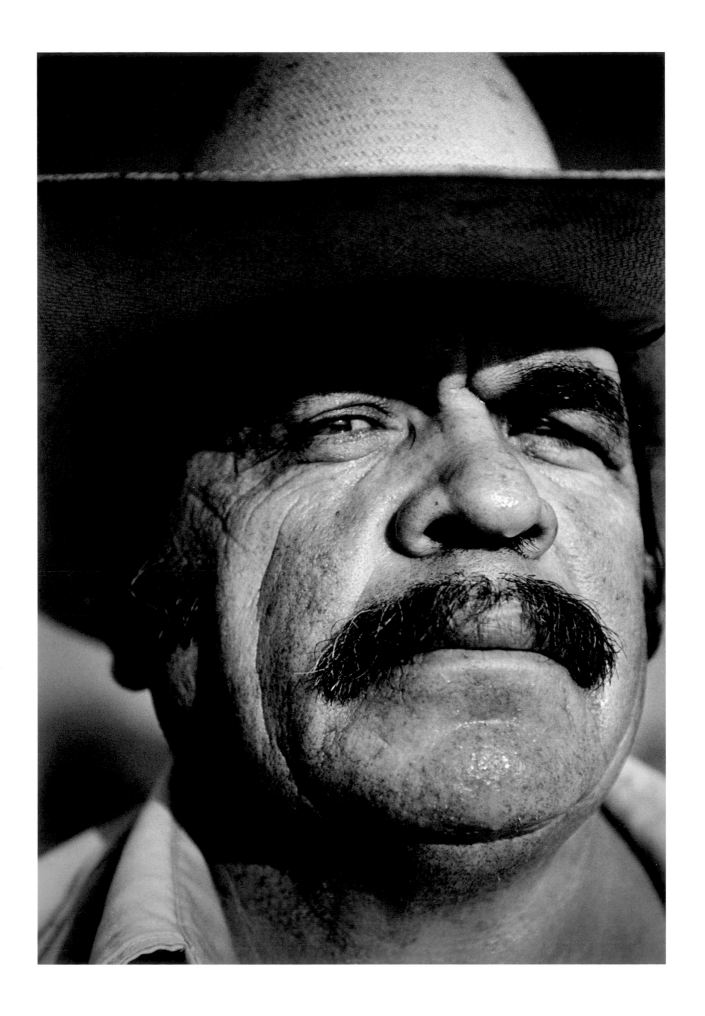

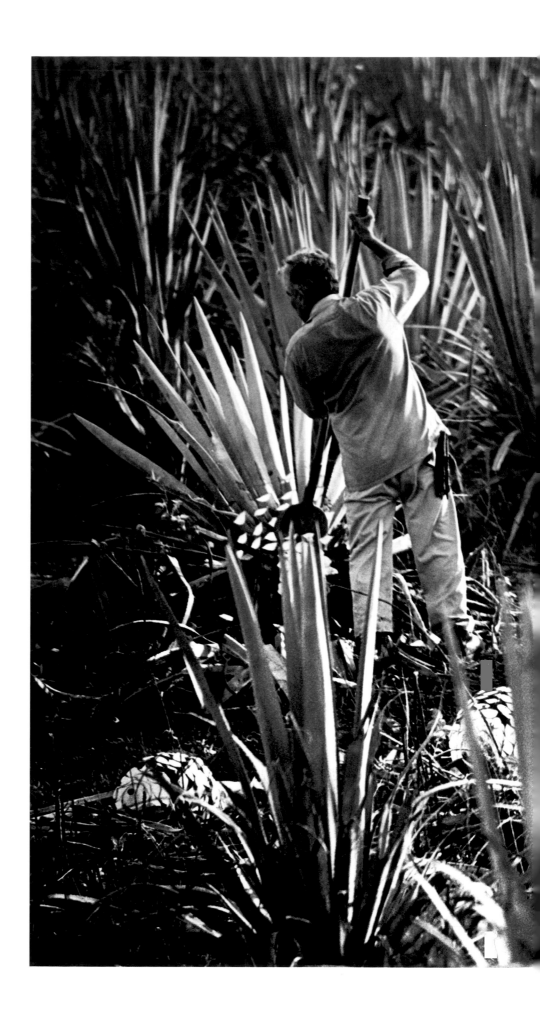

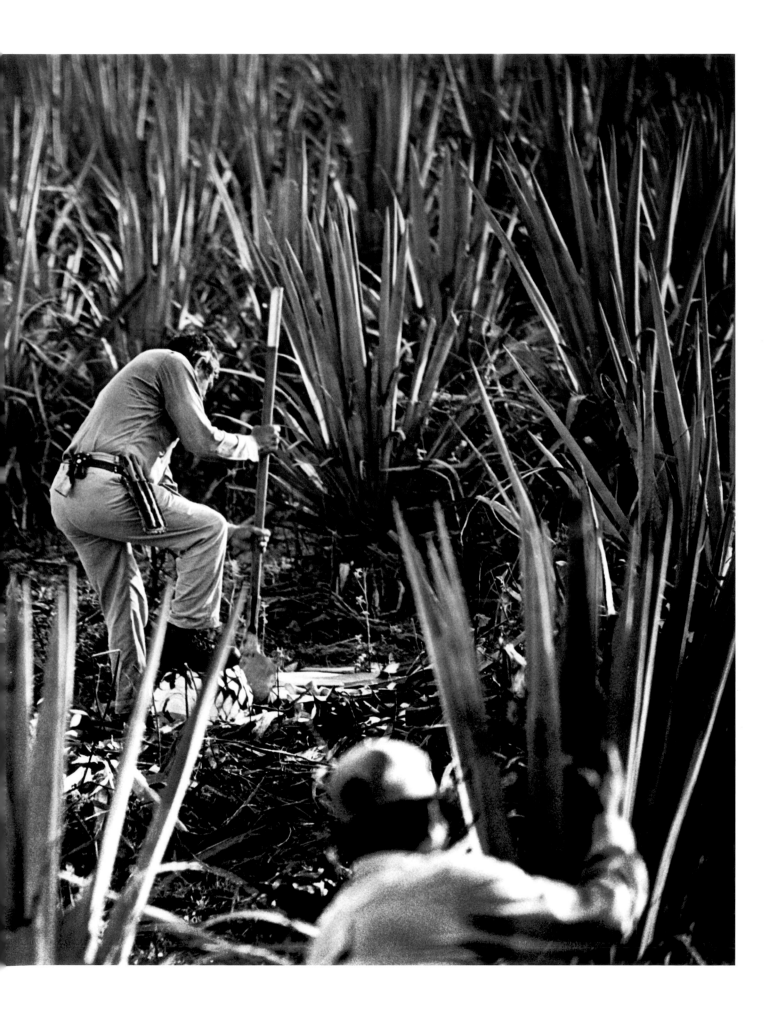

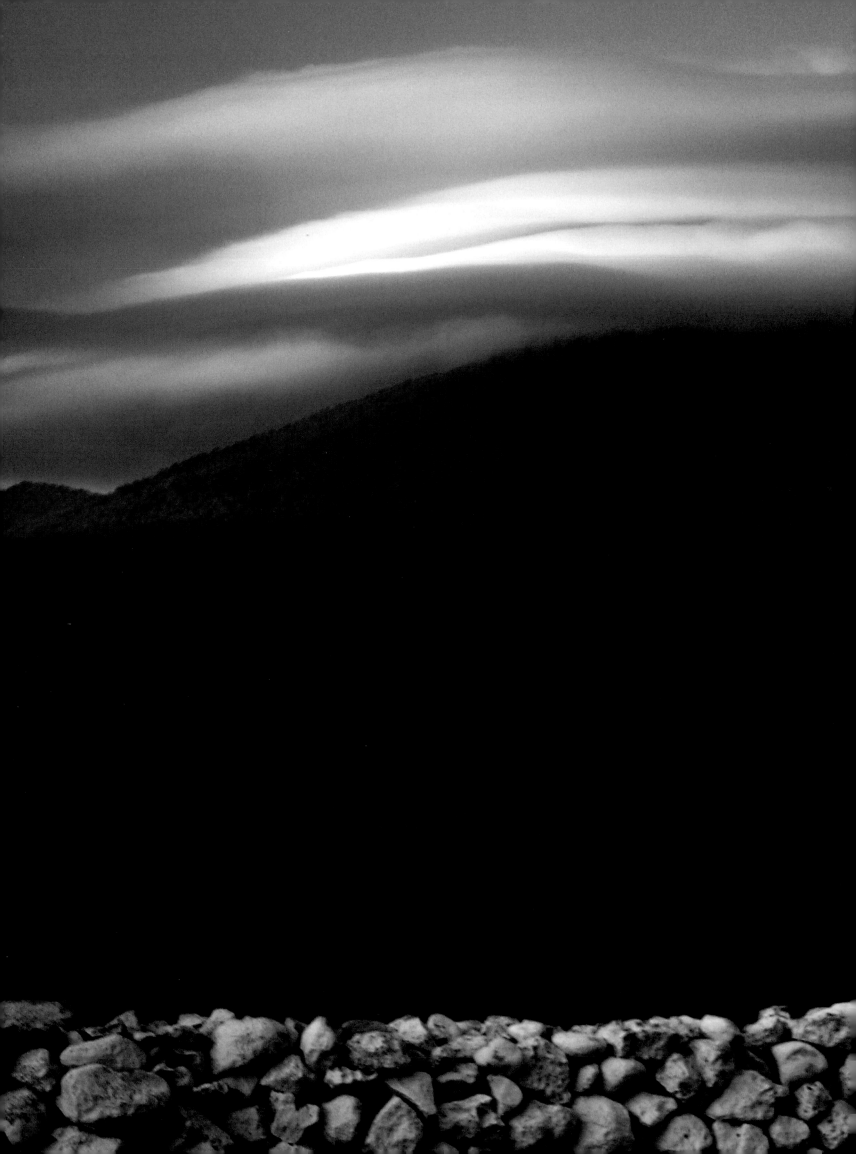

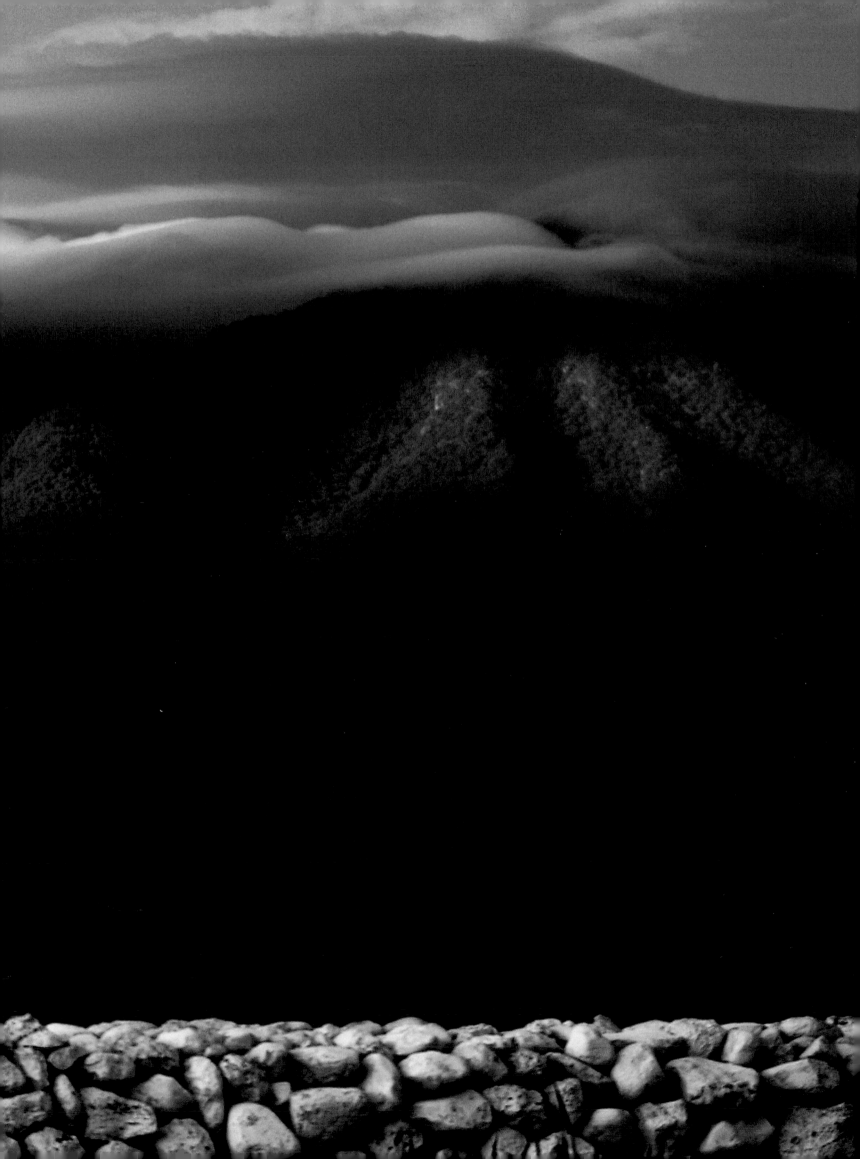

Each agave seedling is cultivated at the hacienda, and is known by the tequila makers as having descended from a previous worthy ancestor. Only the very best are individually selected from thousands of lesser buds, and then planted by hand. This detail seems impossible to believe, as the slightest turn of the head reveals thousands upon thousands of plants pushing up from tidy, endless rows in all directions. It becomes clear that these fields are the result of enormous labor—the men start early and they work fast. Even at this high altitude, the cooling fog will soon be defeated as the sun spreads its familiar fury. A man stops to wipe sweat from his eyes and rest. Miguel is sixty years old and has worked in these fields as a jimador since he was twelve. His wife works at the hacienda and his oldest son works near here, on another *potrero*. His younger son is in the army. He says his whole family going back generations has worked at this hacienda, fathers teaching sons the ways of blue agave. It is very hard work, he says, but it is the life they have. Nothing has ever changed here as far as he knows, and he says he believes it never will.

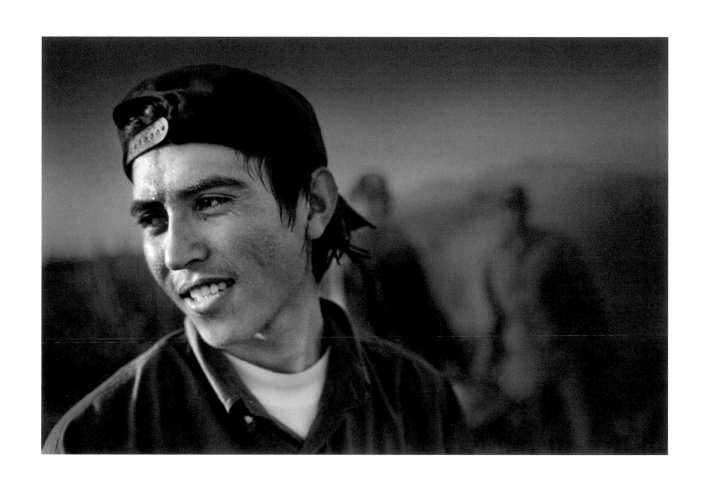

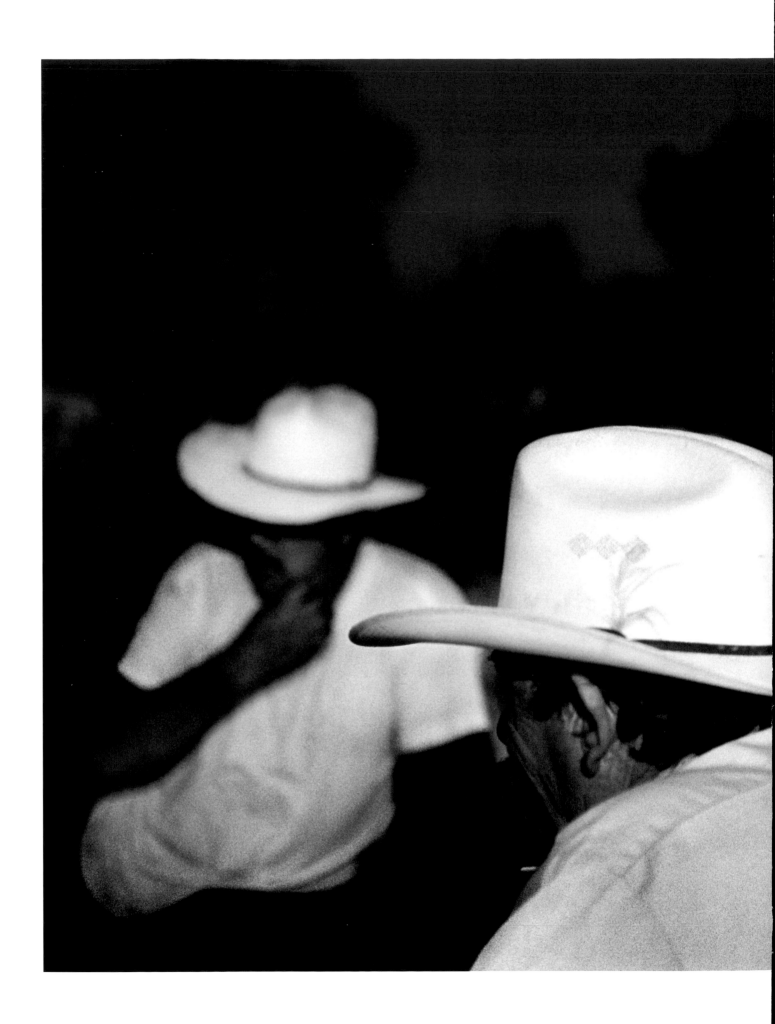

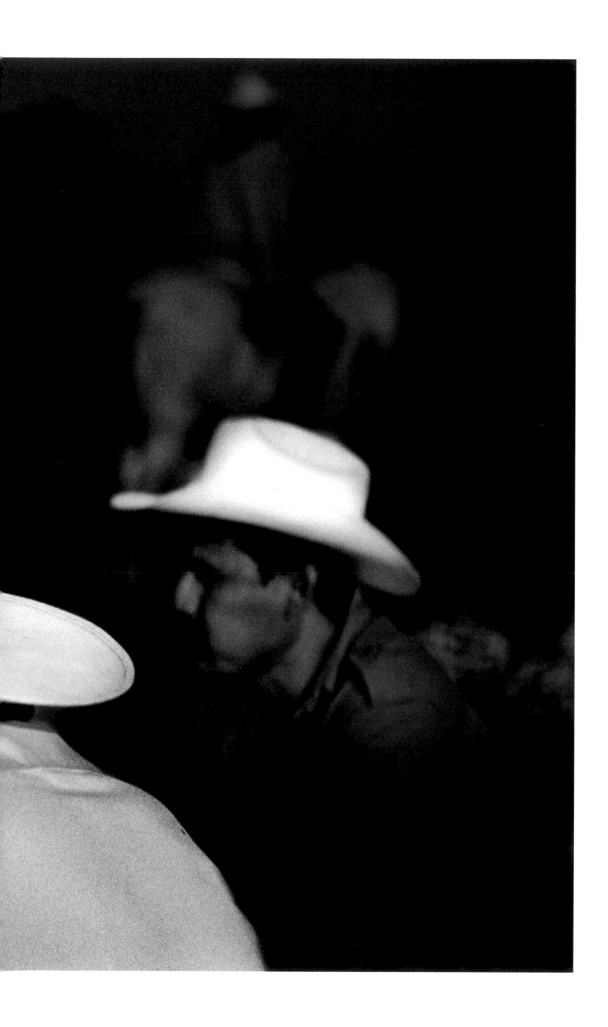

"El sudor del hombre es lo que le da ese sabor al tequila."

"It is the sweat of the man that gives tequila its flavor."

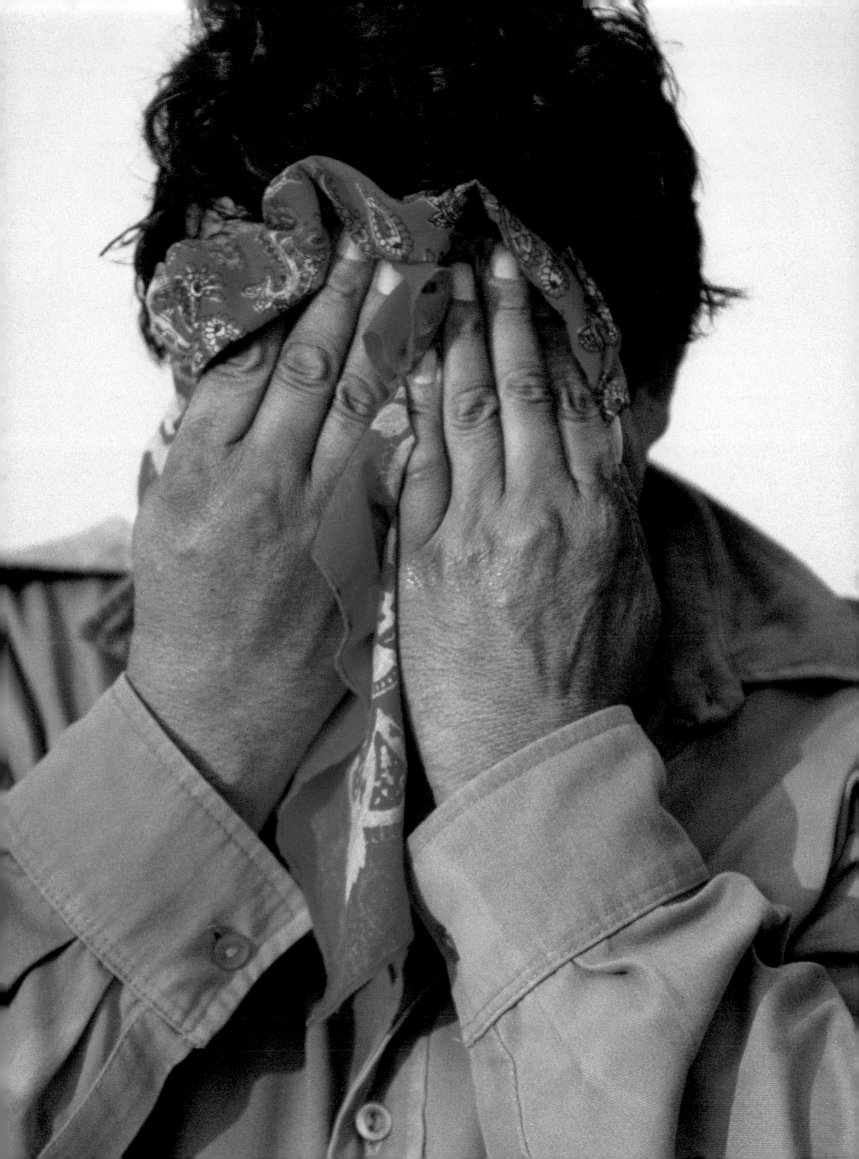

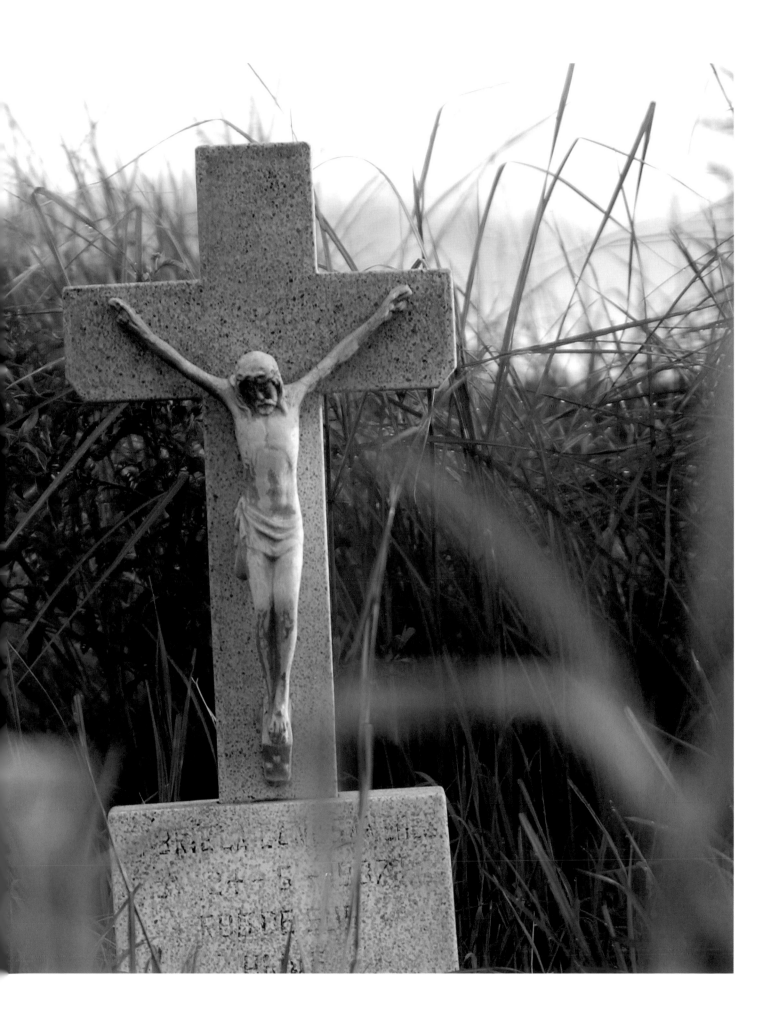

Once the agave is harvested, it is brought to the *destilería* at the hacienda to be manufactured into tequila. Rising up over an old, ivy-strewn wall is the hacienda. It is a sprawling two-story pale yellow and white adobe mansion. There is a short path to the tequila distillery, which sits just behind the mansion. It looks like the hacienda in *Viva Zapata*— the classic film about the Mexican Revolution—in the scene where Zapata is assassinated. Visitors passing through a tall, arching guardhouse receive bland once-over glances from men with automatic rifles. Although they appear bored, there have been occasional gun fights and killings recently over the increasingly valuable agave fields. In the late 1990s, the popularity of blue agave tequilas surged dramatically in the United States and worldwide. Prior to this new demand, growers had actually ripped out agave, planting fields with beans and corn to make a living. This left many tequila distillers unable to fill the quantum leap in new orders. And with the ideal growth cycle of the agave taking upwards of eight years, growers are still catching up with the market.

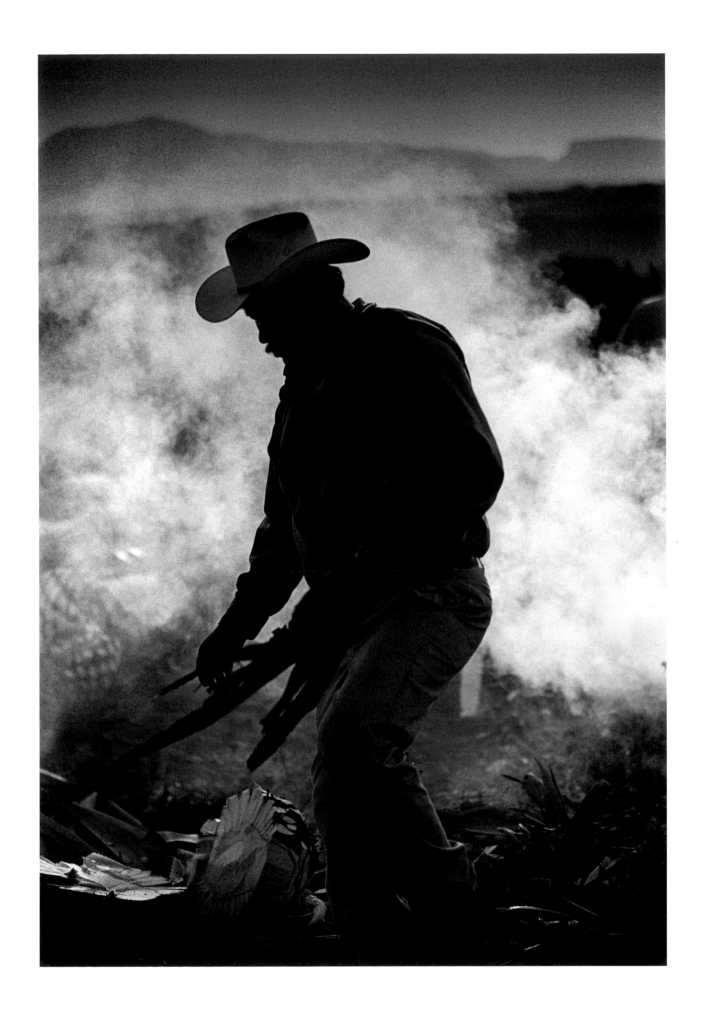

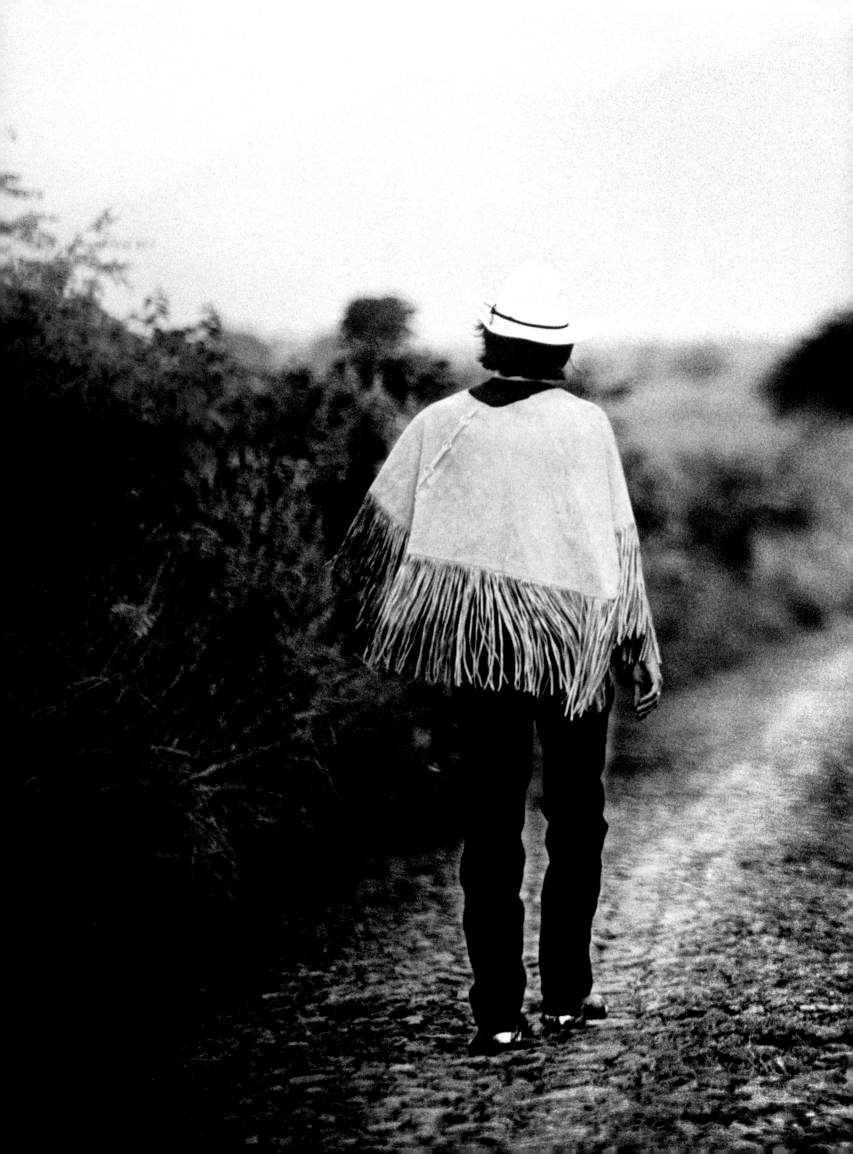

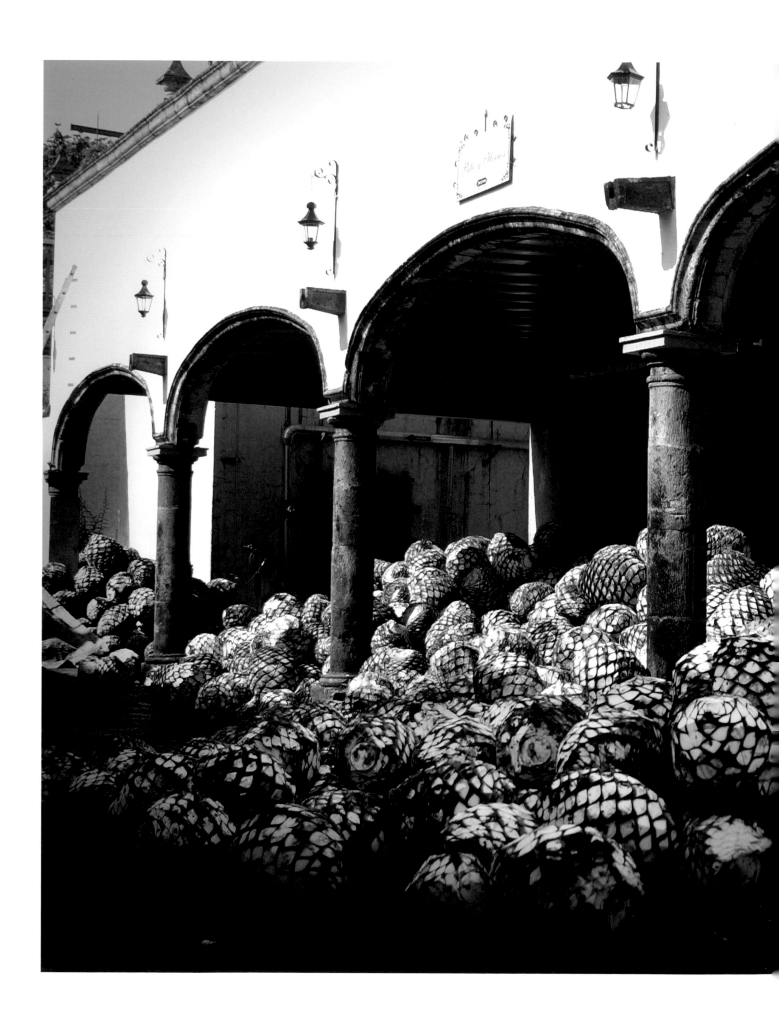

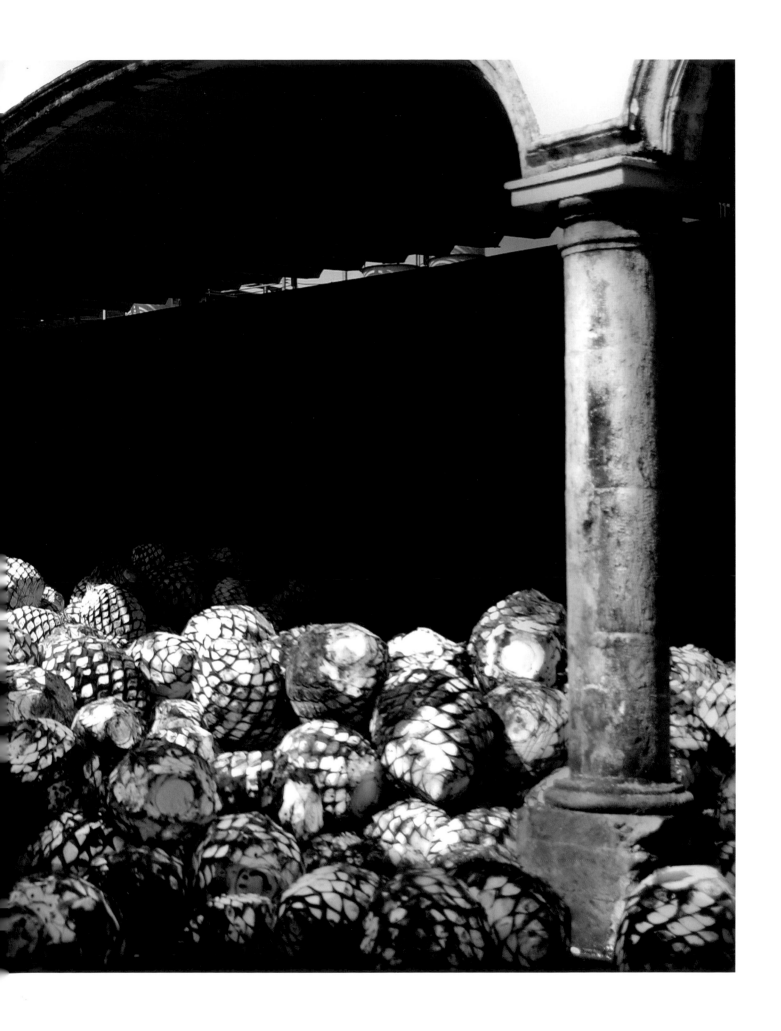

Adjacent to the hacienda is the quiet main street where *casitas*—little cottages given to the workers for life—line either side, with ranchero-style company offices on the end. An old man is sweeping the street with a tall, handmade broom of straw. At the end of this wide cobblestone-covered lane is an archway leading to the main family house, the gardens, distillery, chapel, storage warehouses, various plazas, and stages for folkloric performances and feasts. Trucks are coming in with the newly harvested agave hearts. The men who will unload them drink coffee and remain squatting in the shade against the base of the whitewashed walls. Before the new ways of making tequila began quietly gaining acceptance here, the agave was cooked in pits in the dirt. Now, in this distillery, the harvested piñas are packed into room-size stone ovens where they slowly roast up to forty-eight hours. The softened piñas are taken from the ovens and crushed and shredded to release the juices, now rich with sugars. Special yeasts are added and the fermentation begins, followed by double distillation in the copper kettles that line the blackened stone walls. Most premium blue agave tequilas are then aged in oak barrels, as they are here. A worker points to the electric bulbs and says that this workroom was the first place wired for electricity in all of Mexico. He explains that the owner went to England at the dawn of the industrial revolution 150 years ago to buy electrical generators. A blast of warm air, supersaturated with the sweet, potent aroma of the blue agave, rushes through the room.

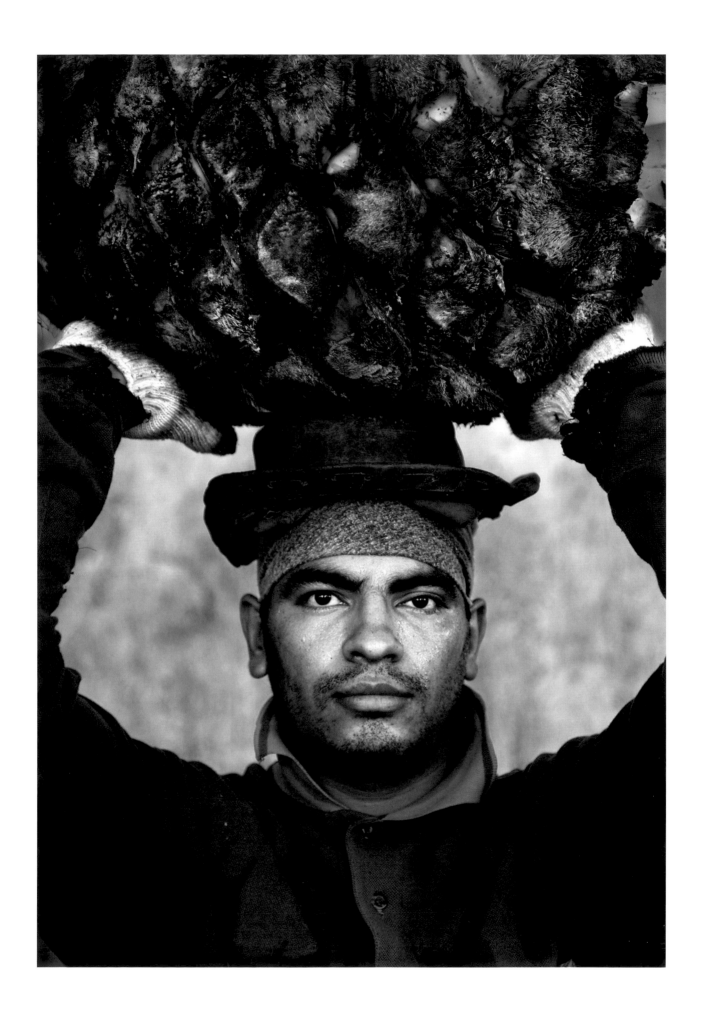

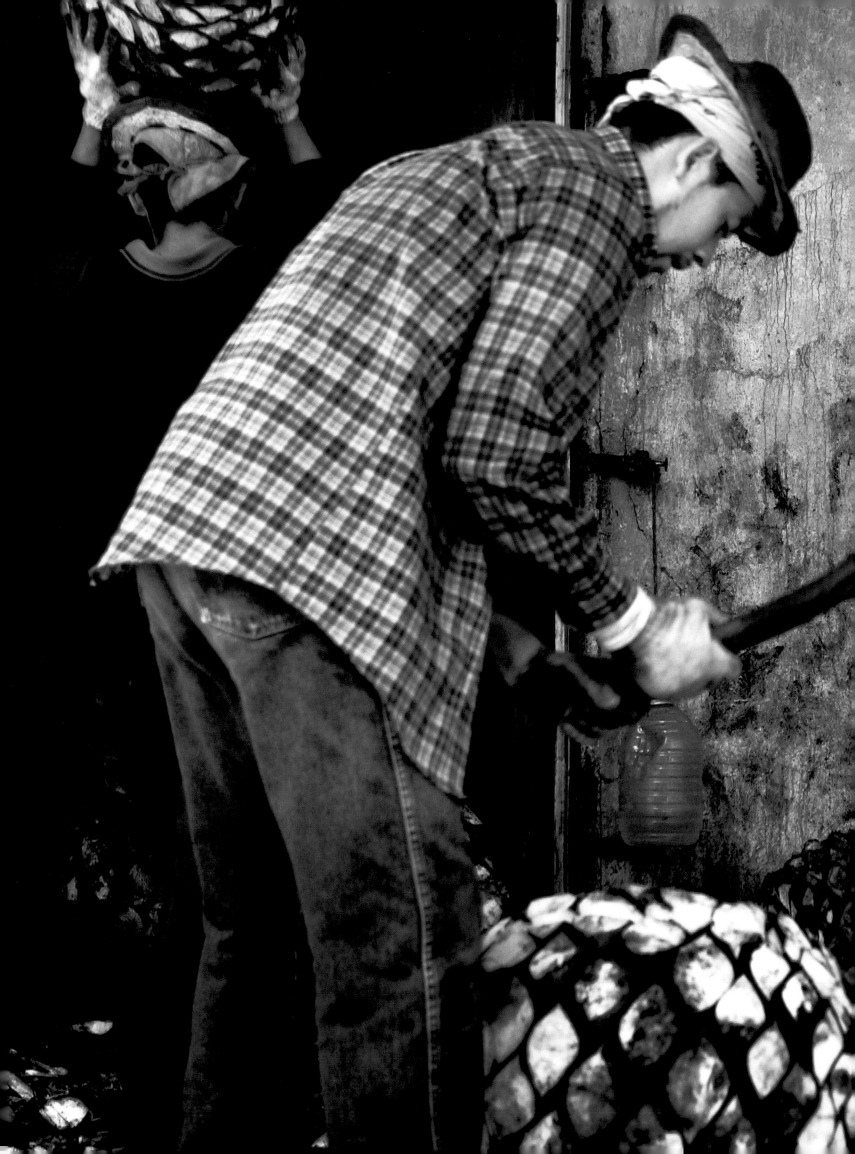

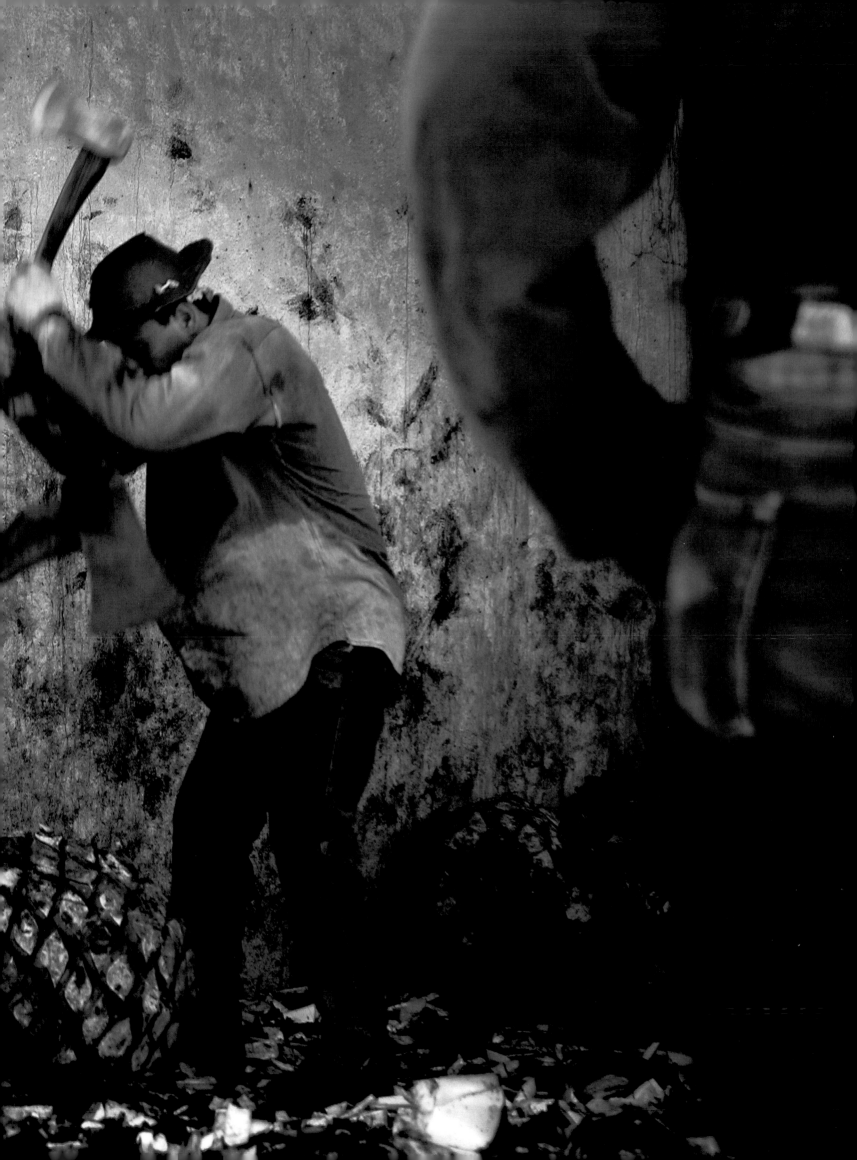

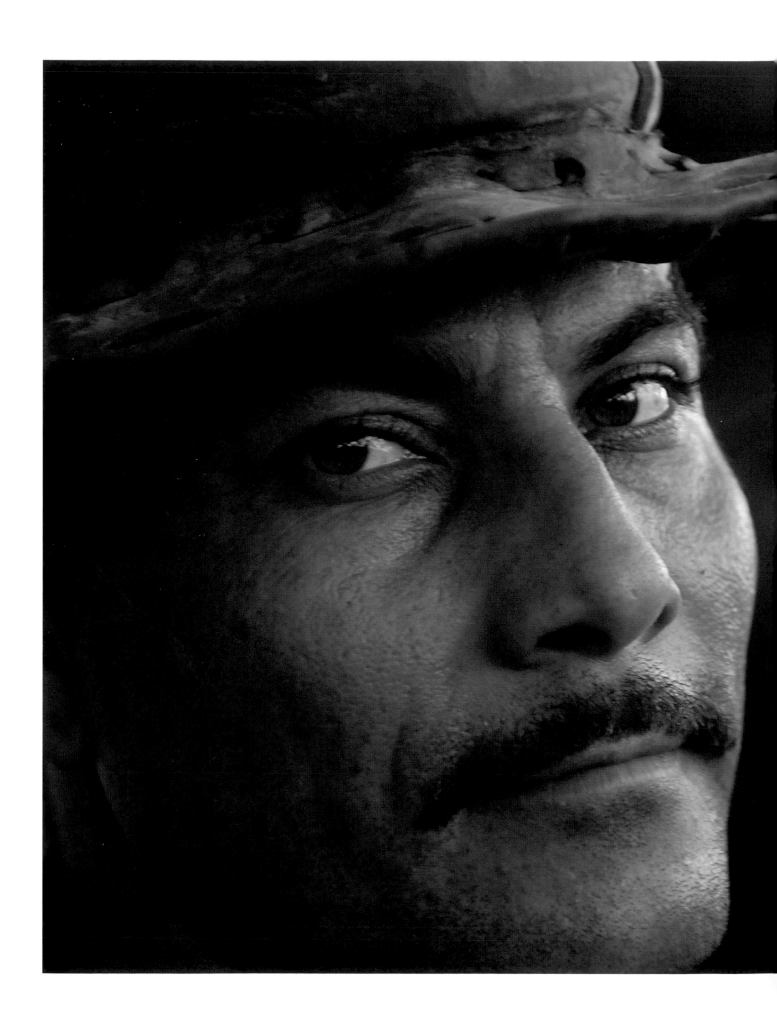

It is dark and cool inside the old distillery, built of stone and bricks turned black from years of crushing, boiling, burning, and cooking. In the first room is a low, circular grinding floor where a giant stone is pushed around a post to crush the hearts of agave after they have been roasted. At different times this stone was pushed by men, burros, and more recently, a tractor. Today men are pushing the stone. The juice runs into the next room through pipes in the floor. Through the stone archway there are more workers, *tequileros*, naked in pits in the floor, working the *must*—fresh agave juice mixed with the pulp of the piñas—by hand and foot in the traditional manner. They stir the must with their bodies to encourage fermentation and to separate strands of fiber and other leafy matter which they pull from the pulpy liquid. The men are naked partly because of traditions going back to the Aztec, who dug pits in the earth, but also because they own only one pair of clothes and the astringent juices will quickly eat through the cotton. Historians speculate that this practice may likely have evolved due to the fact that there are naturally occurring yeasts on skin that start fermentation. Modern methods will soon replace this ancient tradition.

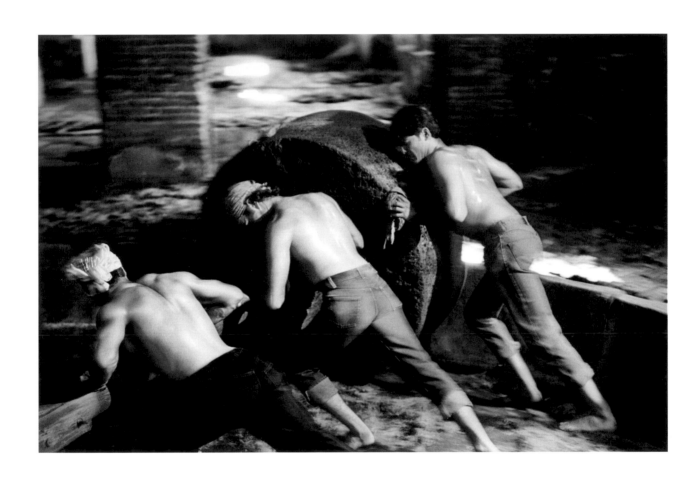

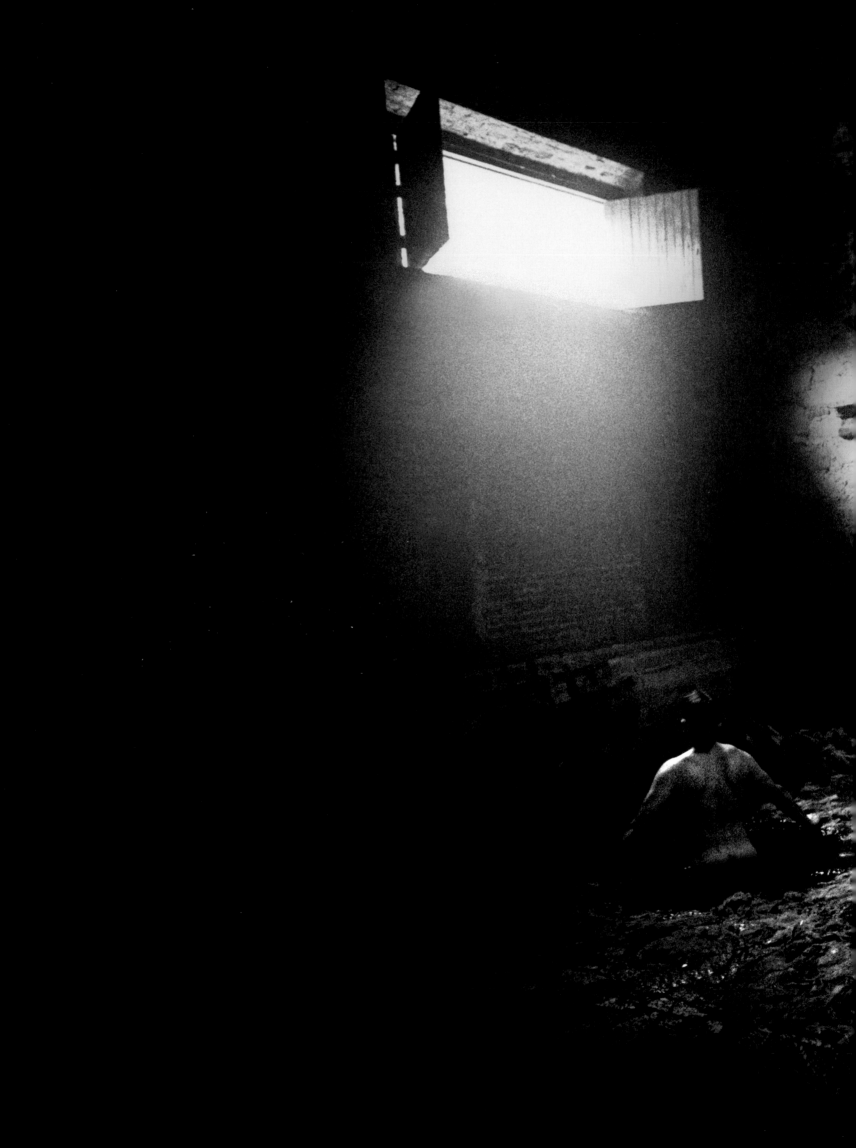

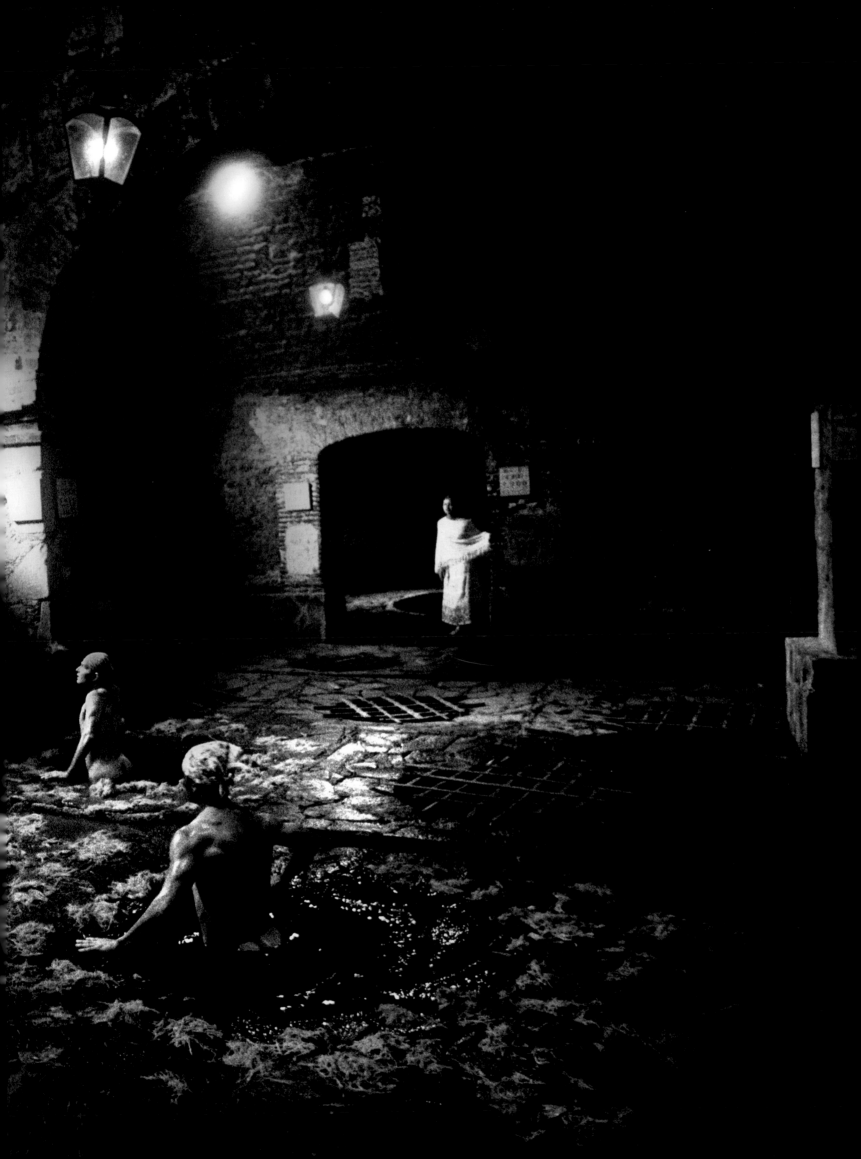

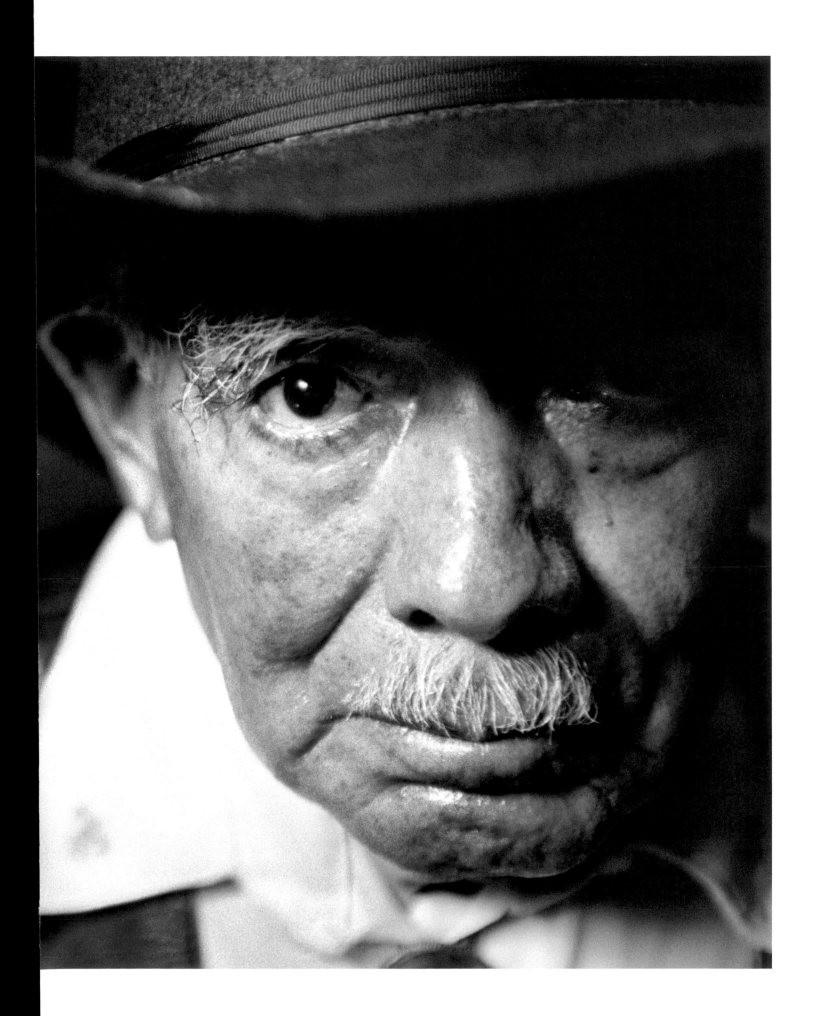

Behind the distillery is a serene patio where tables and chairs are always ready for visitors. *El patron* brings out his most expensive tequila, a venerable *añejo*, aged in oak barrels, and begins a lesson on proper drinking from a crystal snifter. He swirls the glass to show the waist and legs, just as you would with a fine wine. He commands a vistor to first sniff sharply from the close edge of the glass. A high-octane jolt blasts his head to one side. Then a deep sniff from the center. This is a very different fragrance, smoky with oak, yet sweet like fruit. Then a sniff from the far edge of the glass where yet another flavor is revealed—subtle, rounded floral notes. Next, a deep breath and a sip, swirling the tequila a long time in the mouth to lend the liquor some body heat. The swirling reveals the texture and yet more flavor and prepares the body for the liquor. Then a swallow and a slow exhale. Four of the five senses have now been exercised, he says. To use the fifth, he toasts, clinking the glasses together, an almost human-sounding hum emanating from the delicate crystal snifters. *"Salud y pesetas,"* he offers from the classic toast. Completely charming.

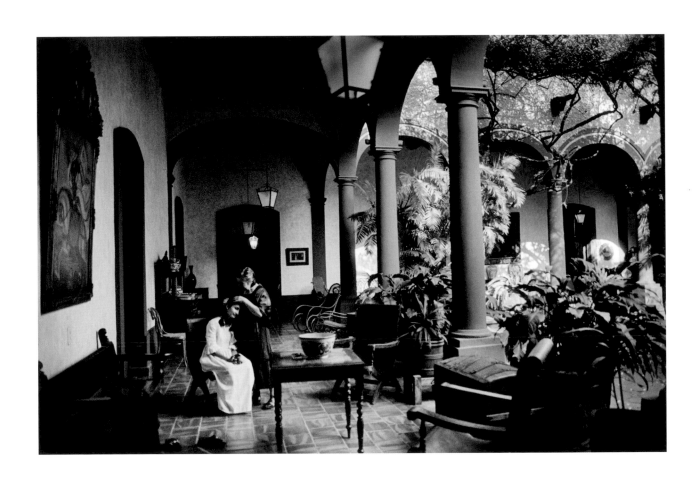

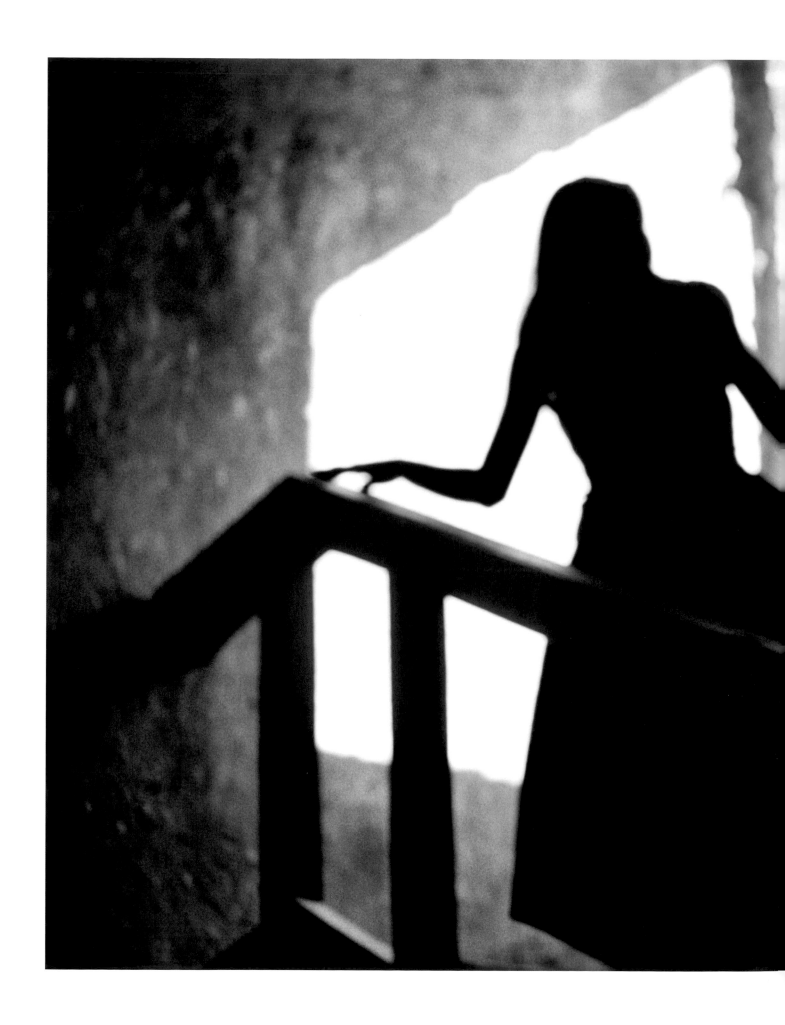

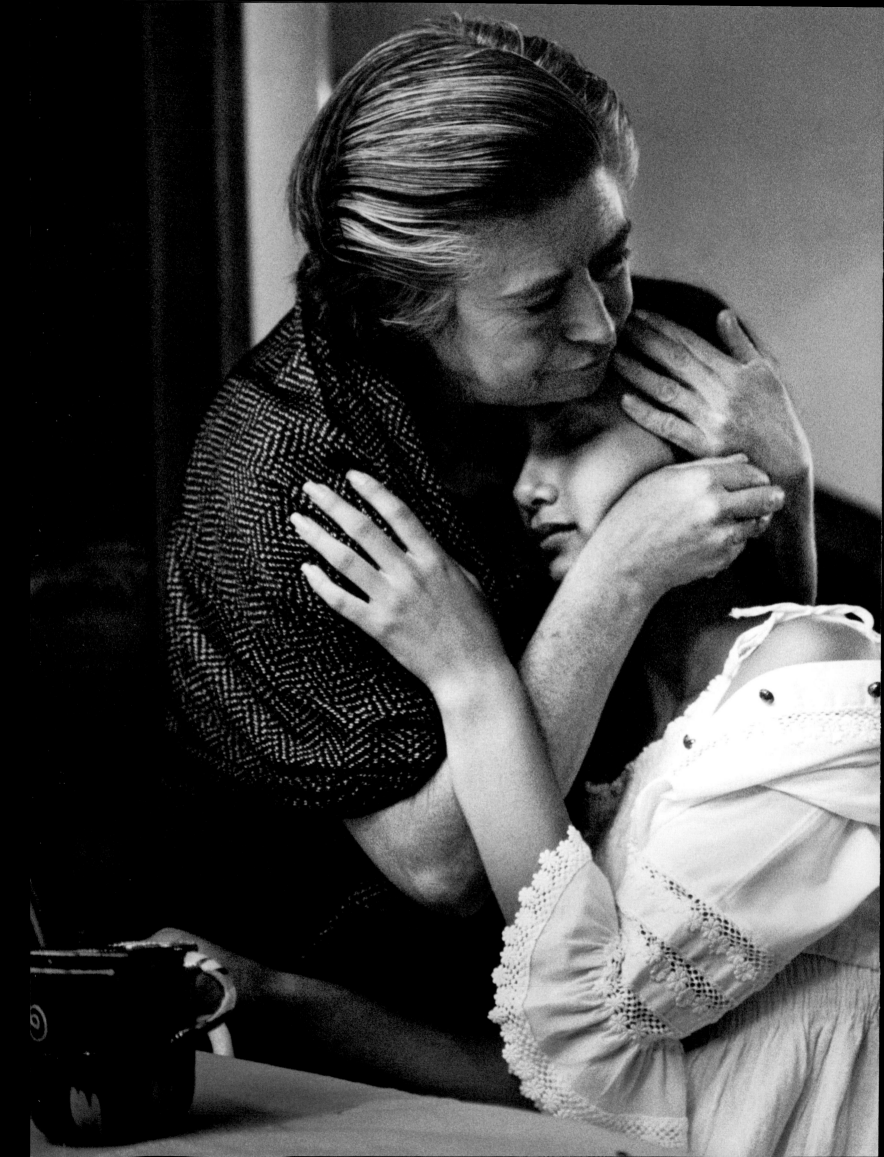

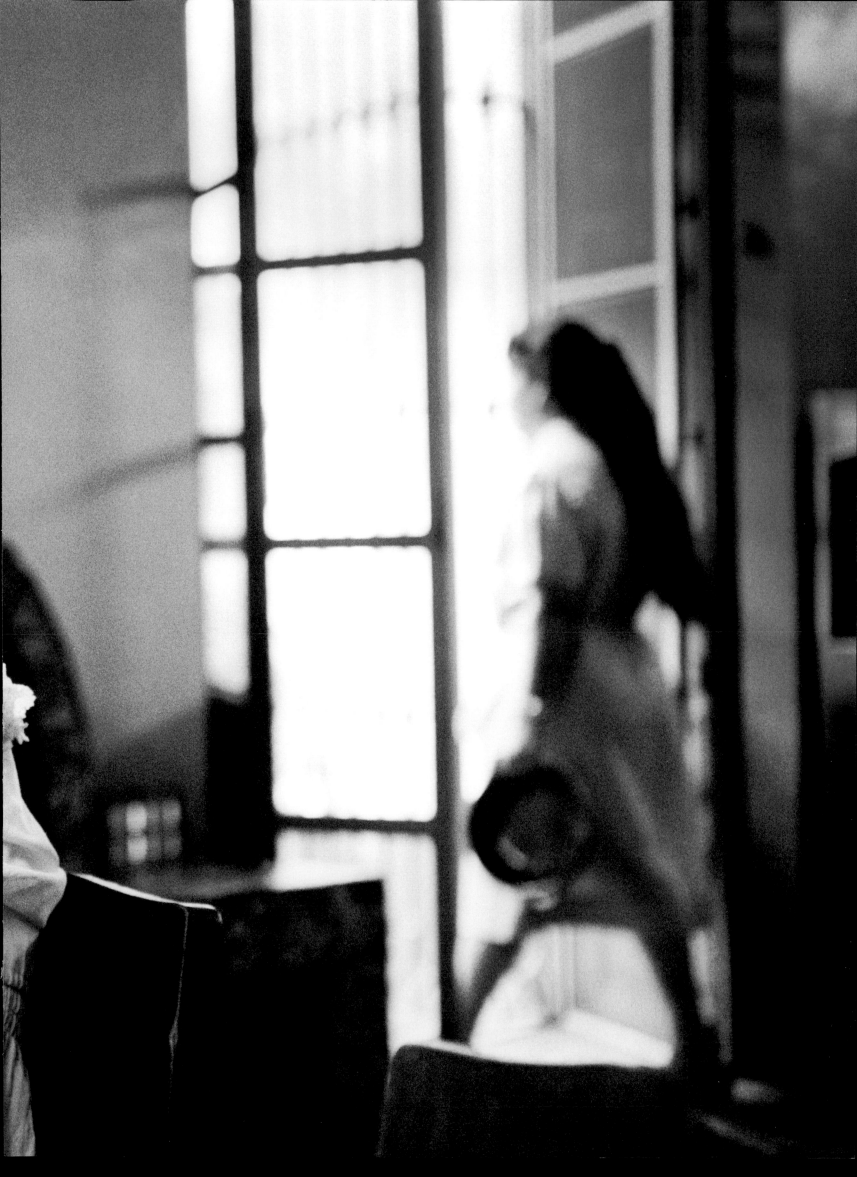

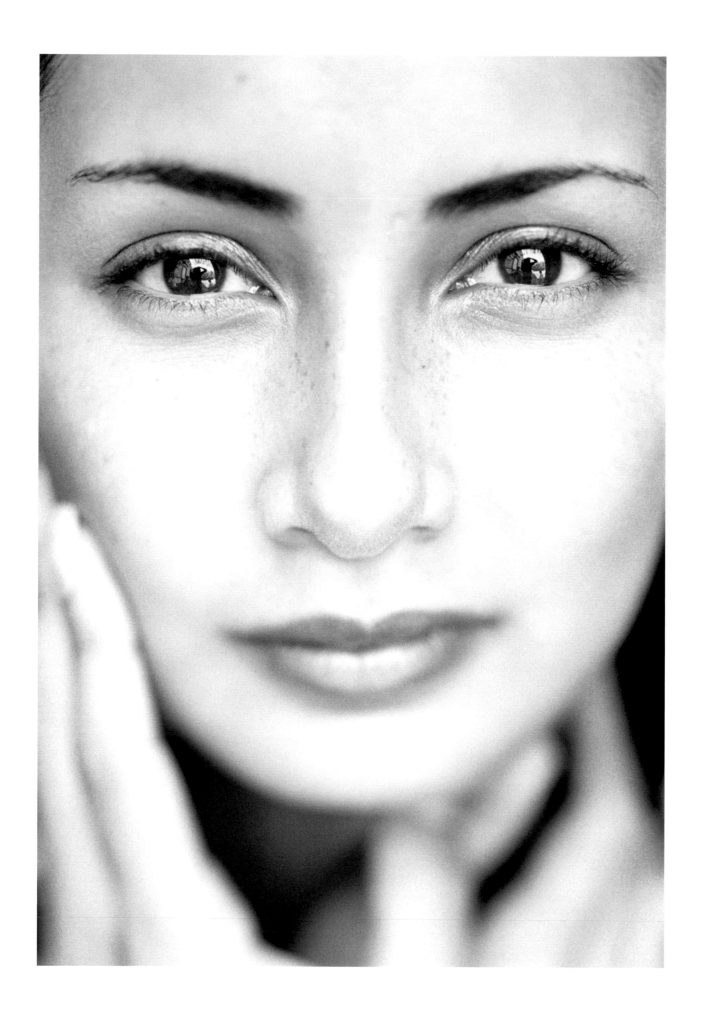

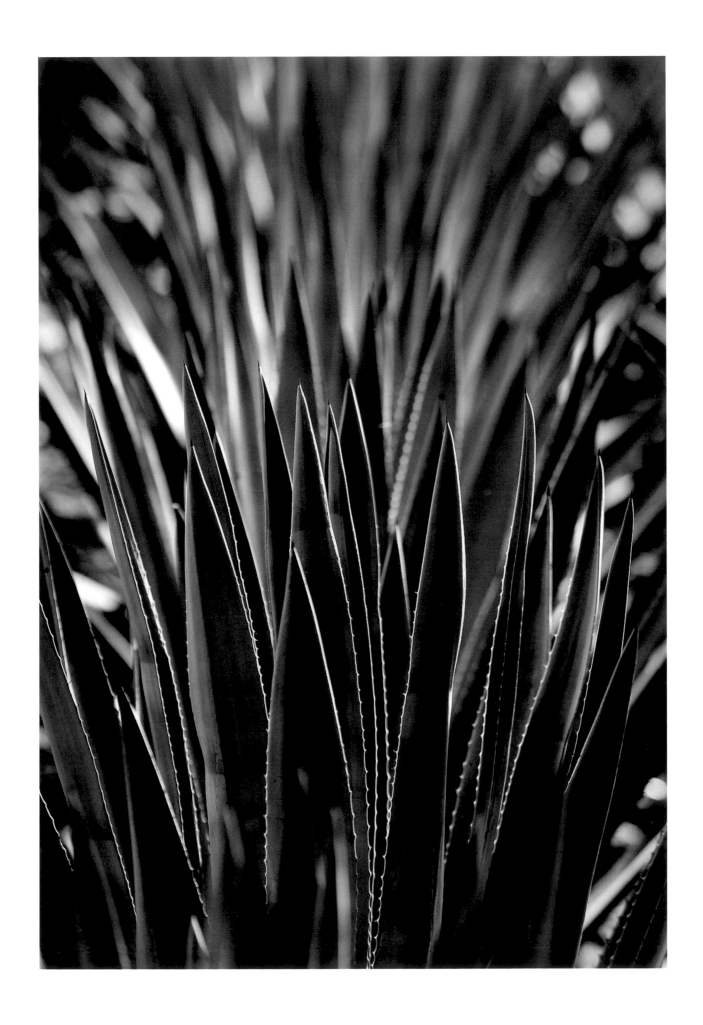

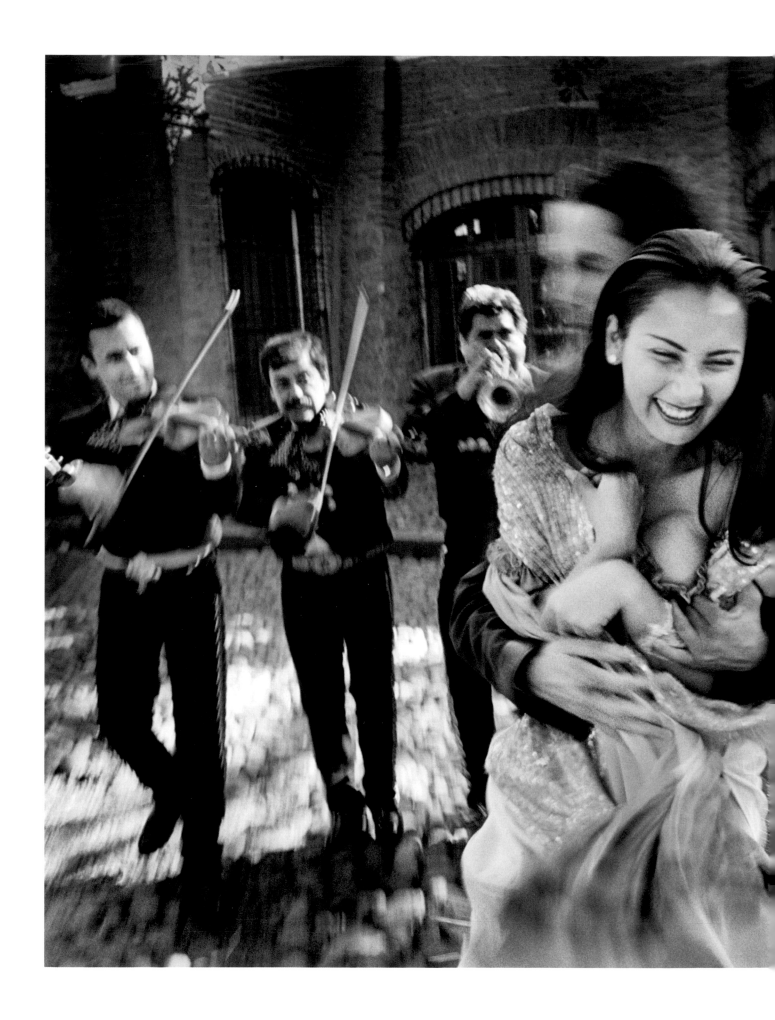

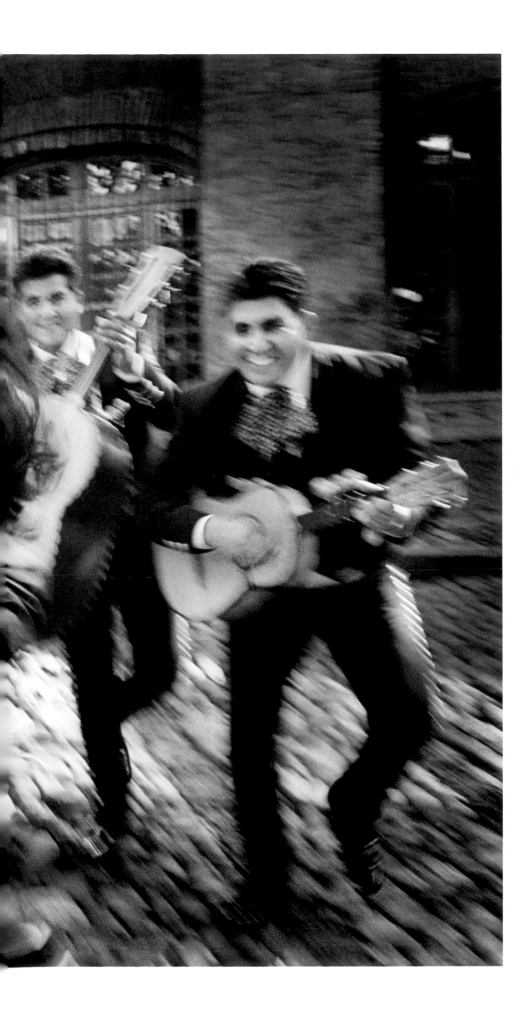

A true hacienda requires a thousand workers, a thousand head of cattle, a thousand hectares, a working business, and, most important of all, a chapel. It was the chapel that allowed this hacienda to grow by trading its use for weddings in exchange for land. The *haciendado* built the chapel even before the hacienda was complete. With each request by a local family to have their children's baptisms and weddings performed there, he would slaughter a cow, then make from its hide a long string. He attached this cowhide string to a stick and laid it across the land, pacing off a parcel that would then become his. Plot by plot, he amassed land in this way over the years. This story contrasts sharply with the way many other haciendados created their domains. They often forcefully took land as they wanted, usually from Indians and small villages. Still, the vast majority of haciendas disappeared in the Revolution and through various agrarian reforms in the years that followed. Today, weddings are still performed in the chapel here.

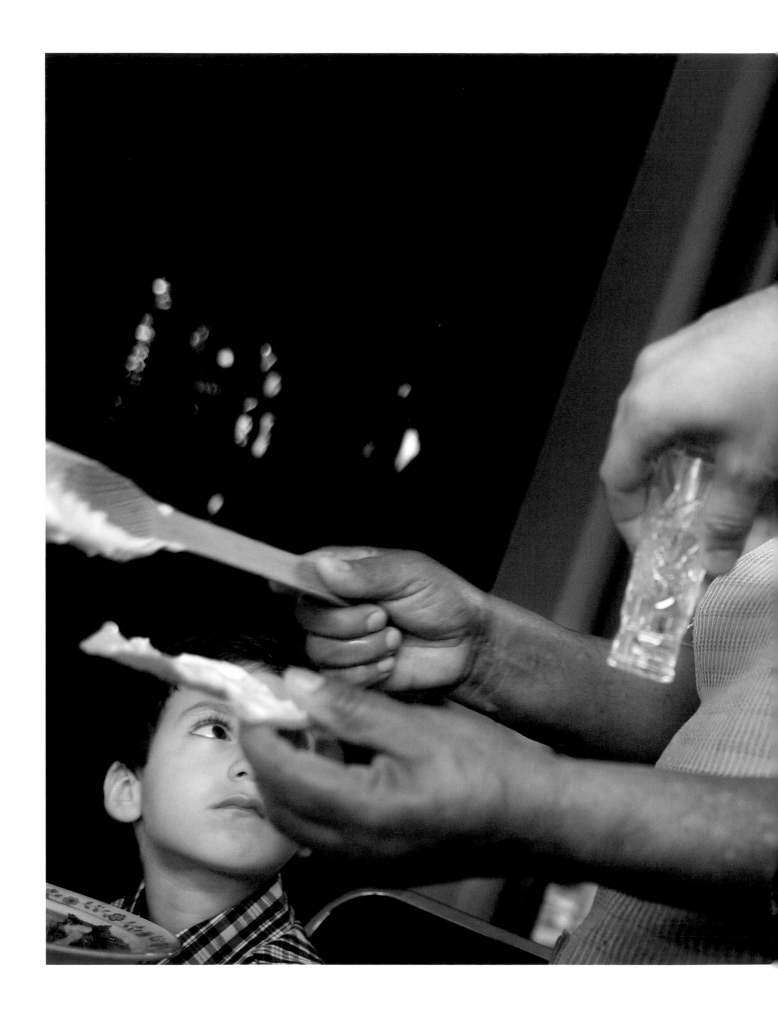

In every plaza, the Mexican flag is always flying, unfurling its archetypal storyboard, mostly unobserved, but worth a closer look. An extremely violent scene, nature at its most instinctive, sits at the center. It depicts an eagle fighting a snake—the struggle for life and death. The green, white and red colors of the flag symbolize hope, purity, and the blood of the heroes who fought for independence. According to legend, the gods had advised the Aztecs that they would know the place to build their city when they saw an eagle perched on a prickly pear tree, devouring a serpent. The Aztecs saw this mythical eagle on a marshy lake that is now El Zócalo, the main plaza in Mexico City. The eagle on the flag is terrifying in its beauty and power, mercilessly ripping apart the snake. A brutal, primal symbol reflecting the reality of nature and life on earth, and here in Mexico.

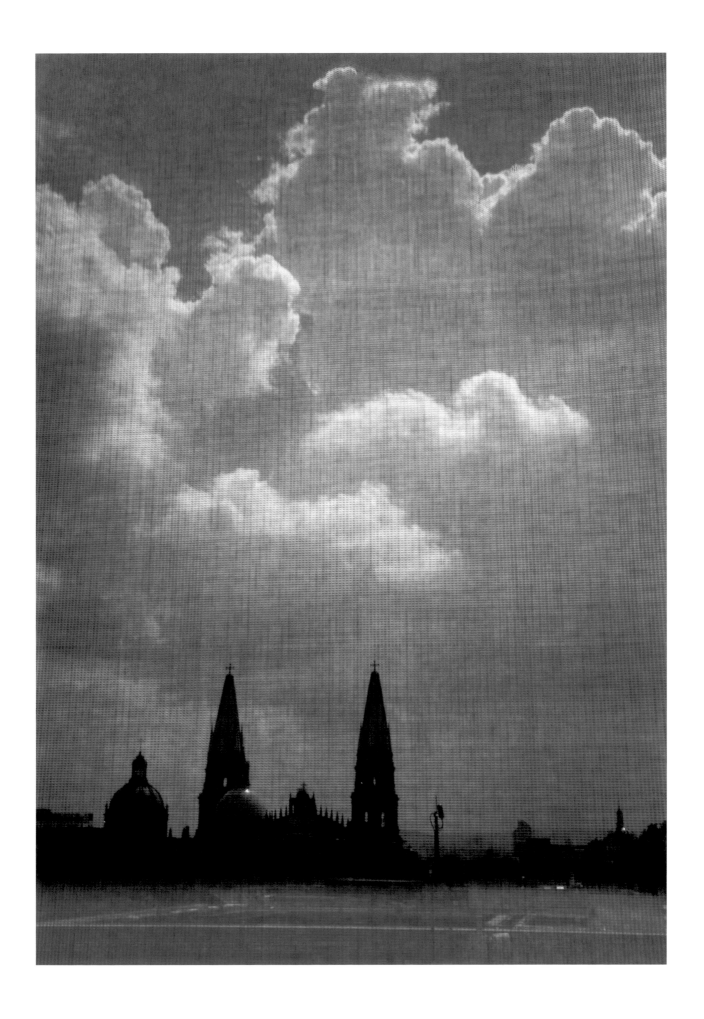

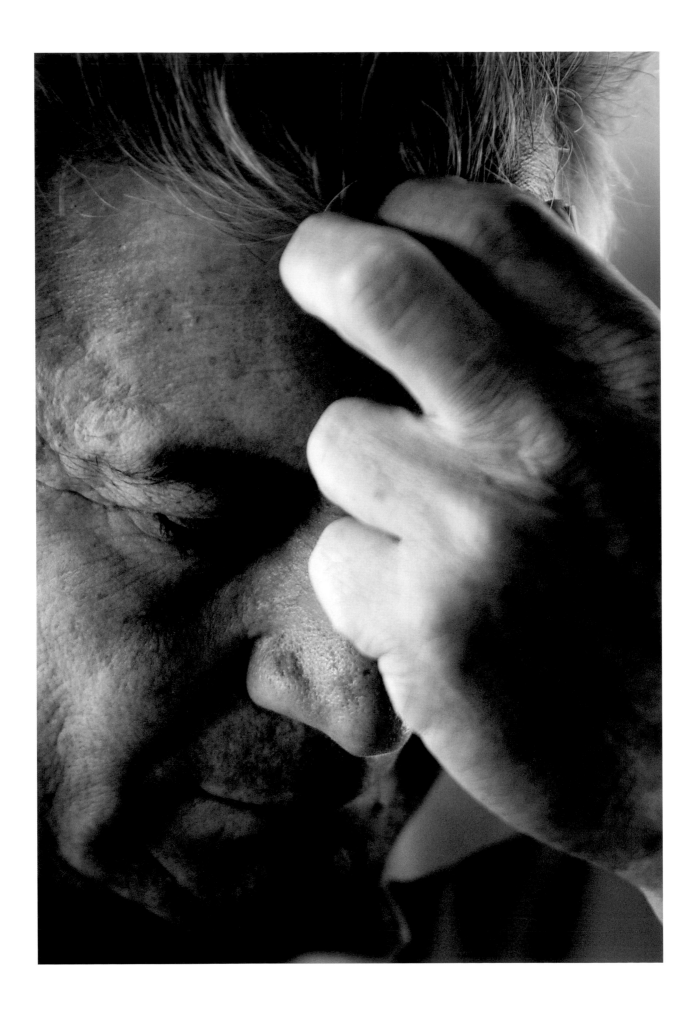

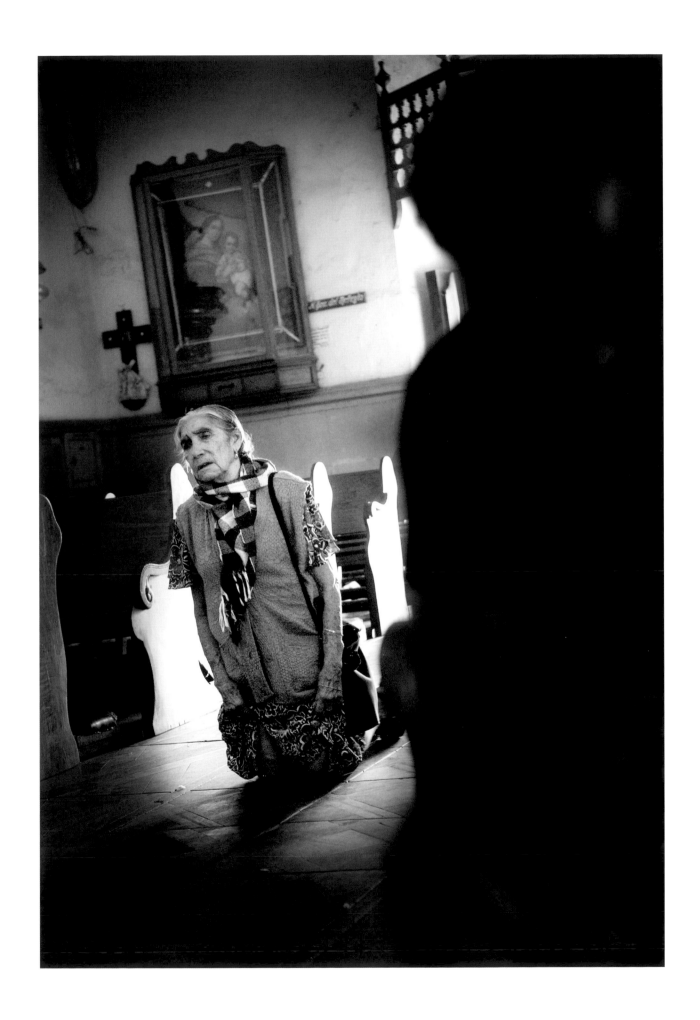

"El tequila hace al hombre que confiese… hasta lo más profundo de su machismo."

"Tequila makes a man confess even the most profound reaches of his machismo."

76

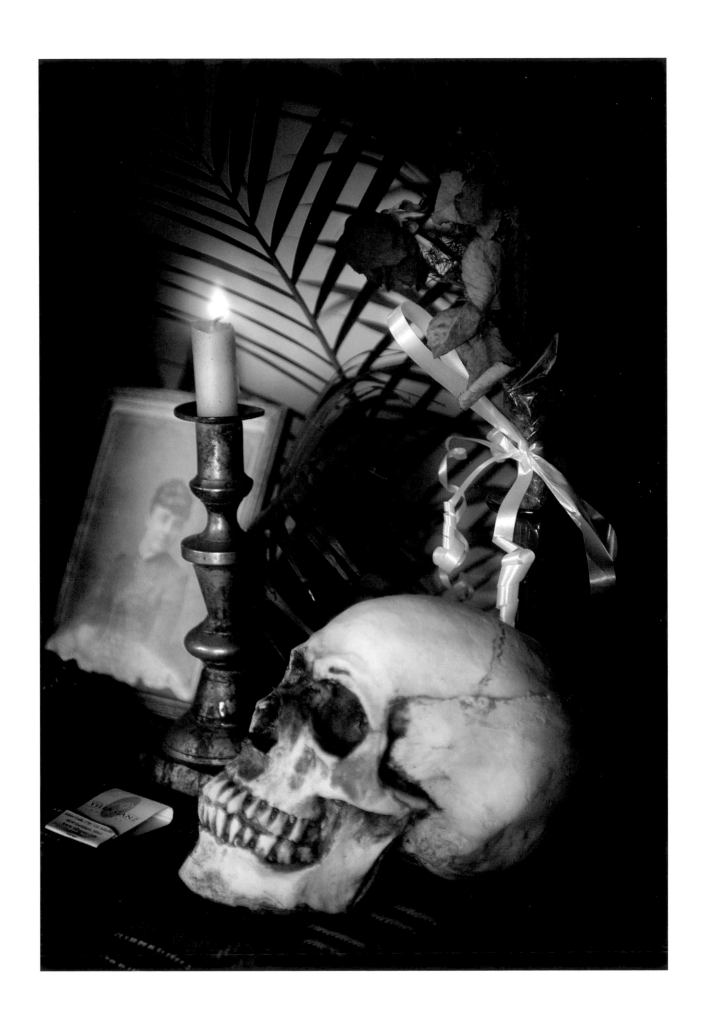

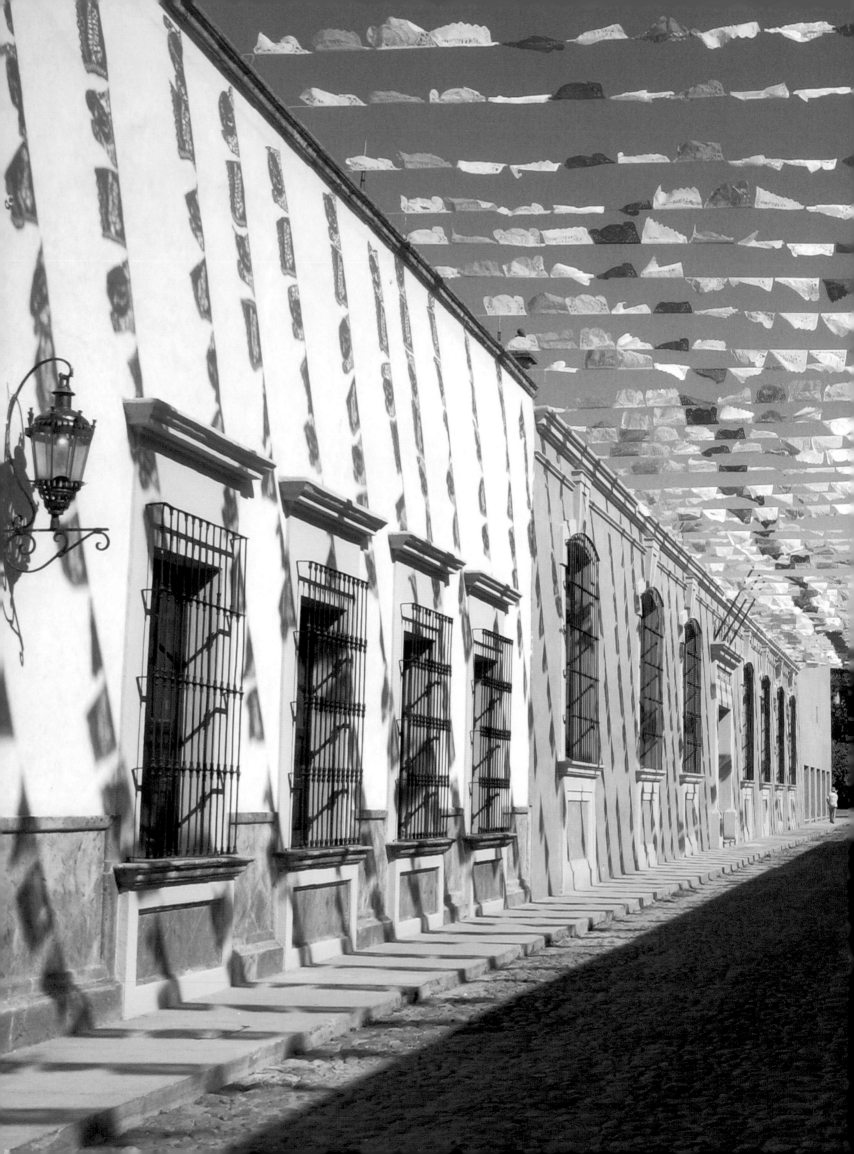

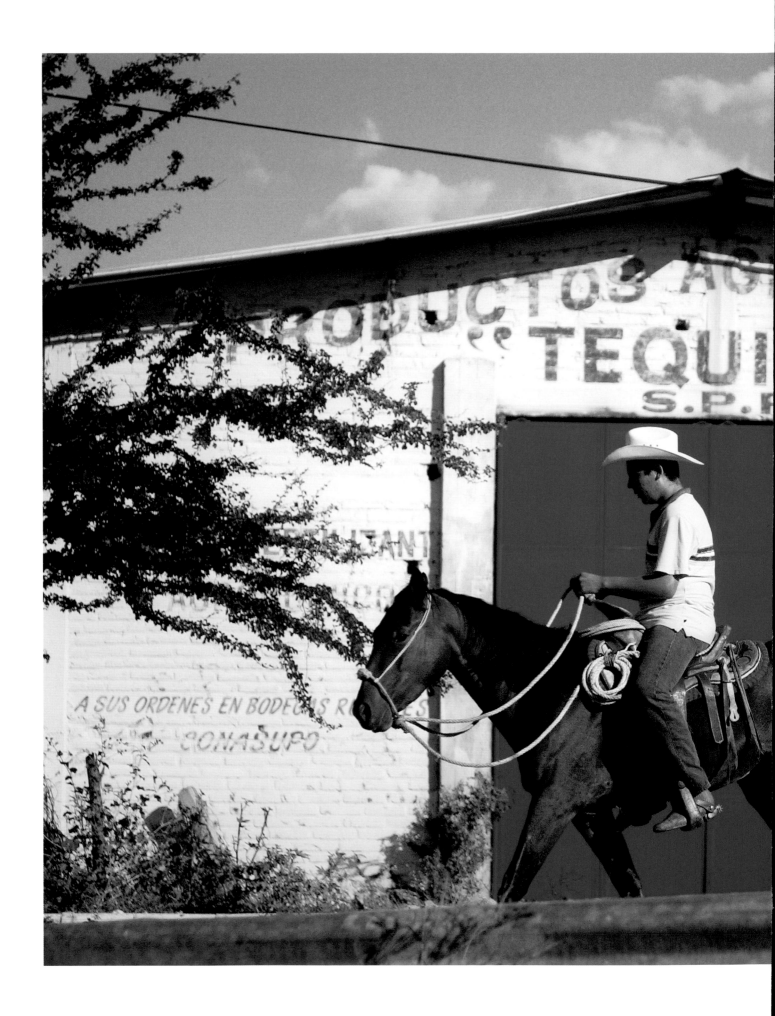

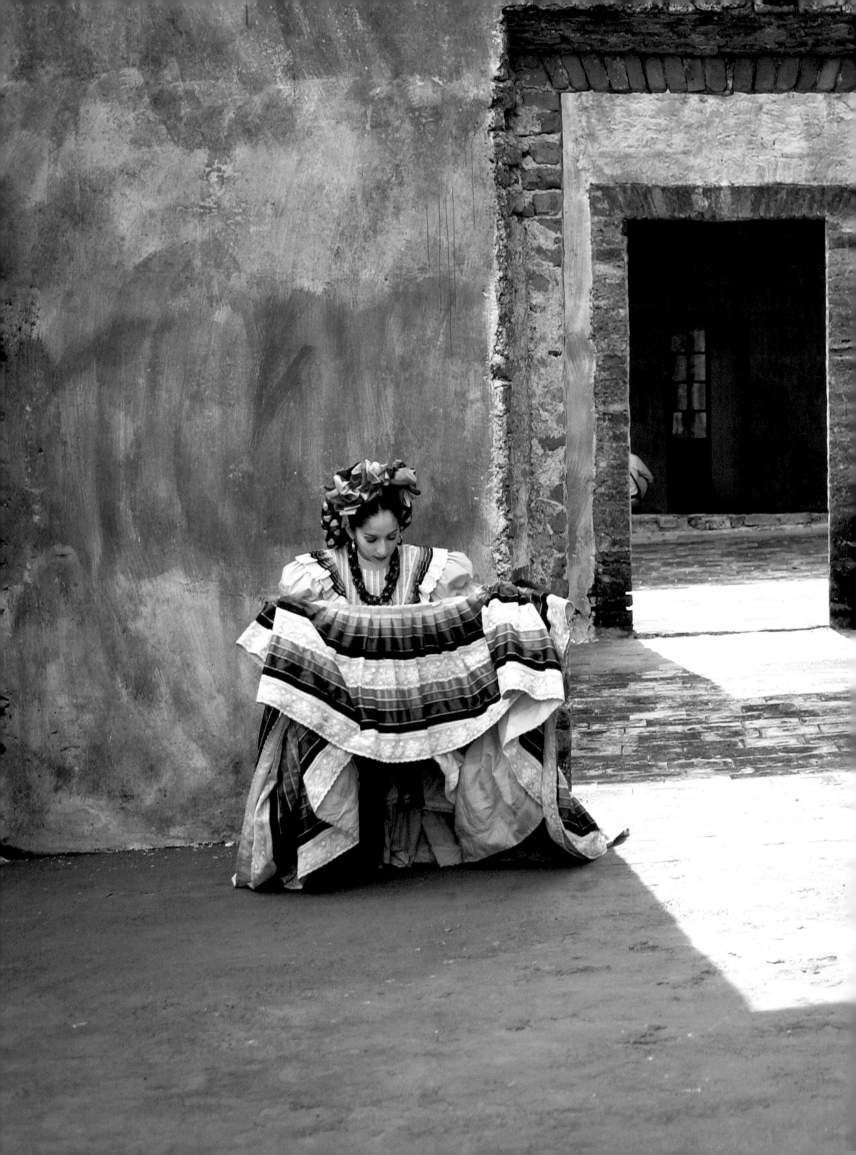

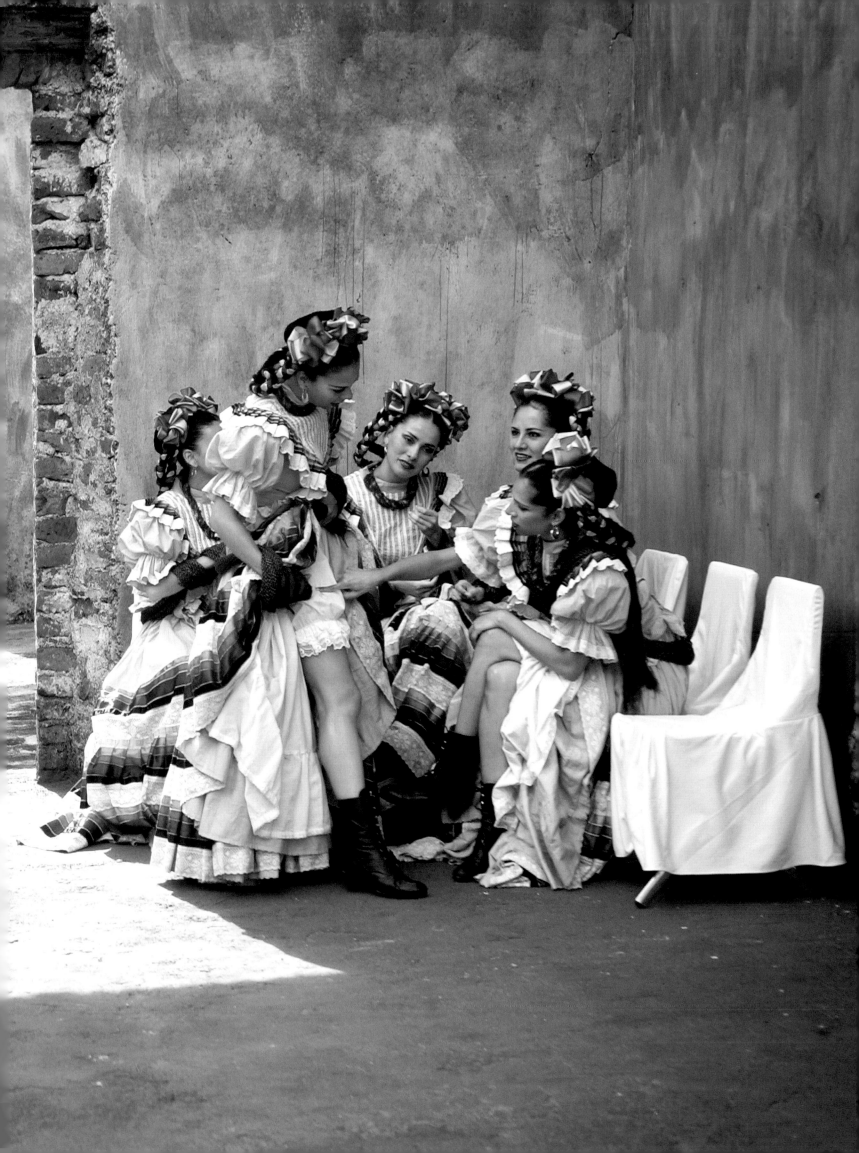

"Come with me," murmured the young bullfighter known as El Conde, gesturing silence to his visitor as he led the way behind the bullring into a warren of narrow walkways. The tangy smell of the bulls reveals their presence nearby. Then with a sharp look, El Conde nodded and motioned to go forward through an aperture as narrow as a child's body. Suddenly the visitor faced a pair of large, nervous bulls, less then twenty feet away, with nothing but air in between. "Stay absolutely still," he whispered. Not a problem. Swinging their massive heads to see the intruders, the bulls snorted, their muscles twitching with raw power. "No one has ever seen this before. A bullfighter never shows himself to the bulls outside the bullring dressed in his *traje de luces*, my 'suit of lights.' It's bad luck," he explains, boldly breaking with an old tradition and superstition. He steps out to face the bulls, immaculate and elegant and less than ten paces away from serious harm. He stares them down calmly, settling them. Extreme macho. Yet there is much more than simple machismo at work here; the encounter is almost supernatural. El Conde is utterly convincing in this private display of the total dedication and courage required to fight bulls.

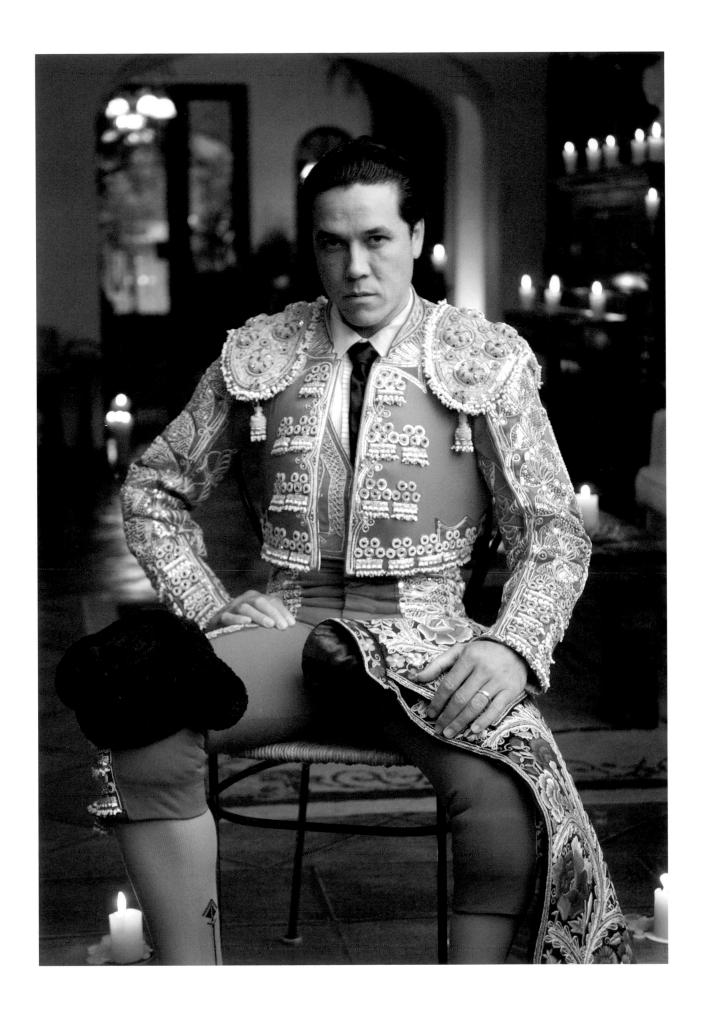

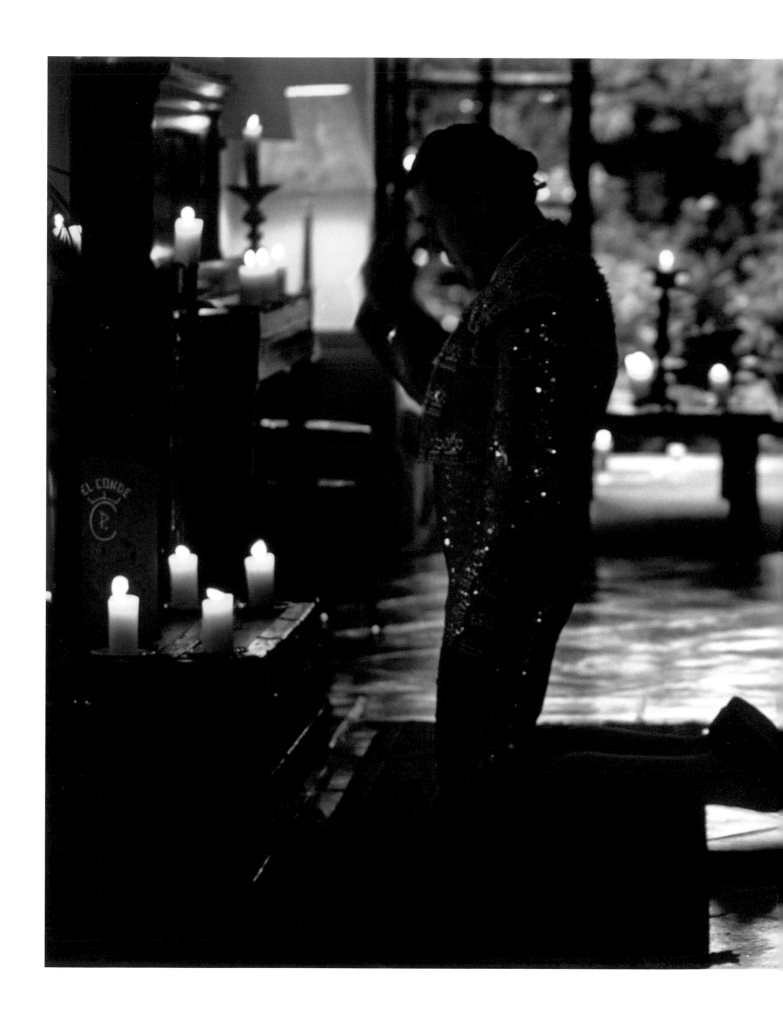

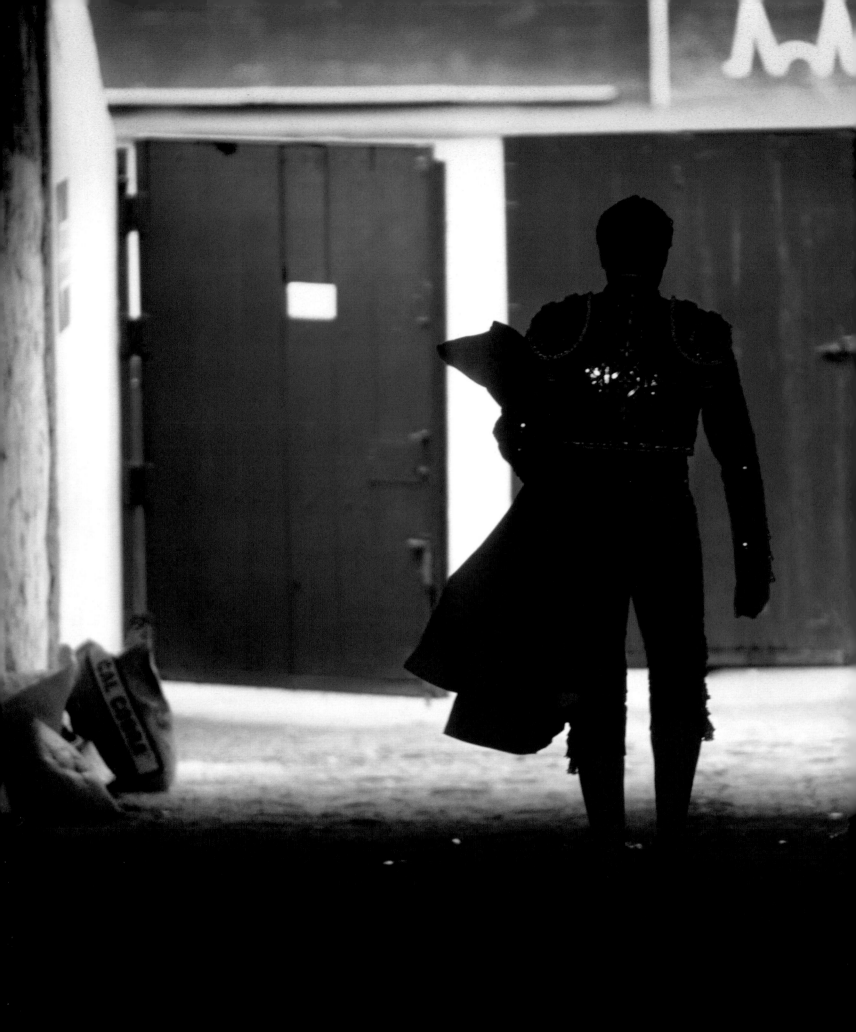

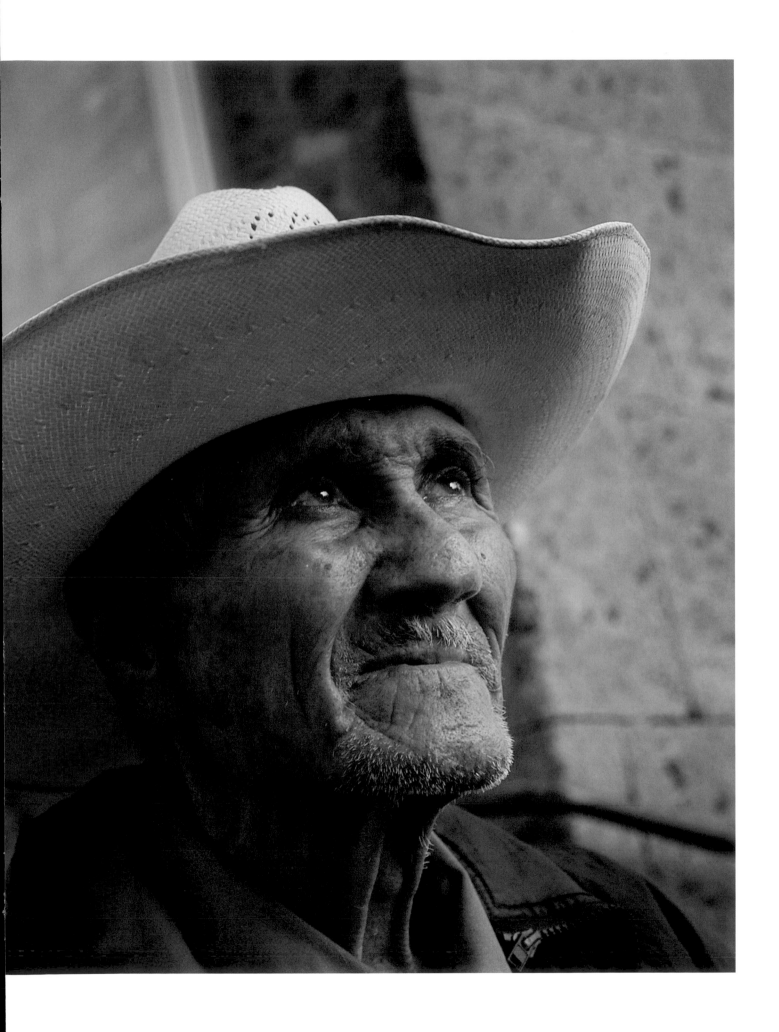

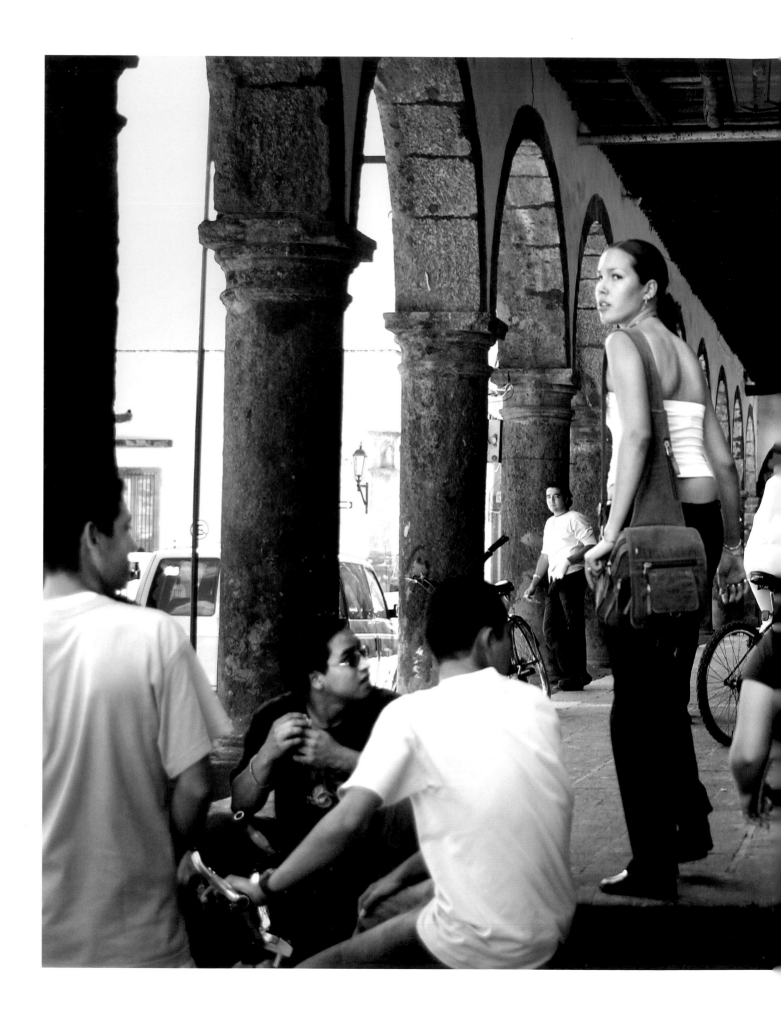

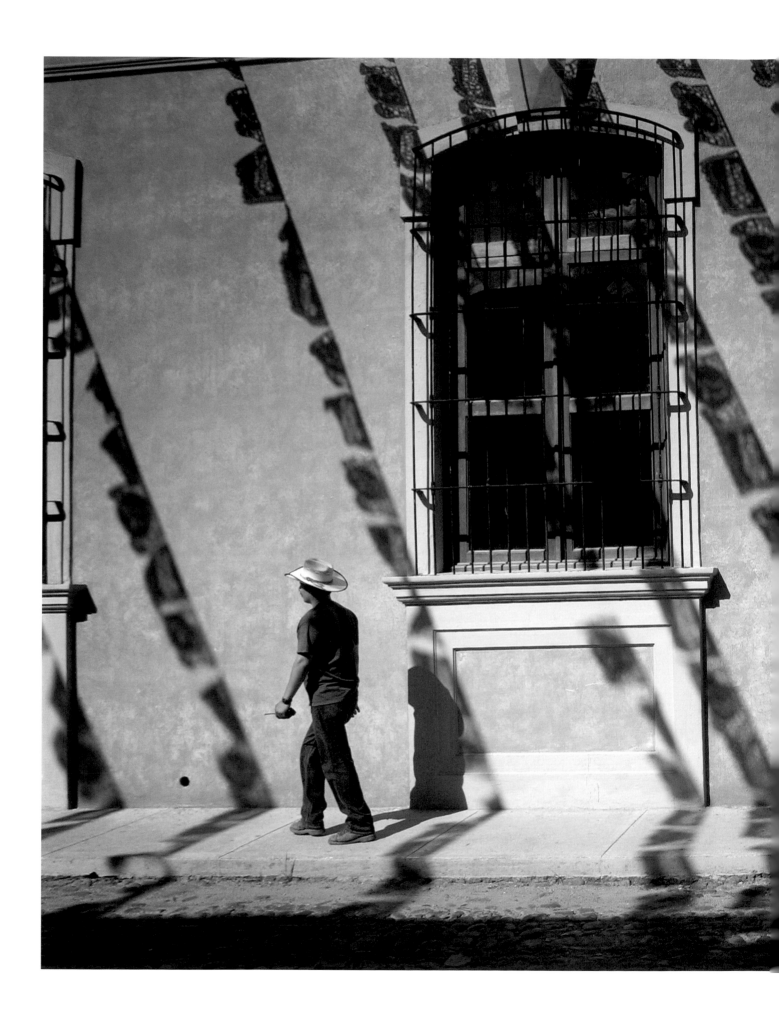

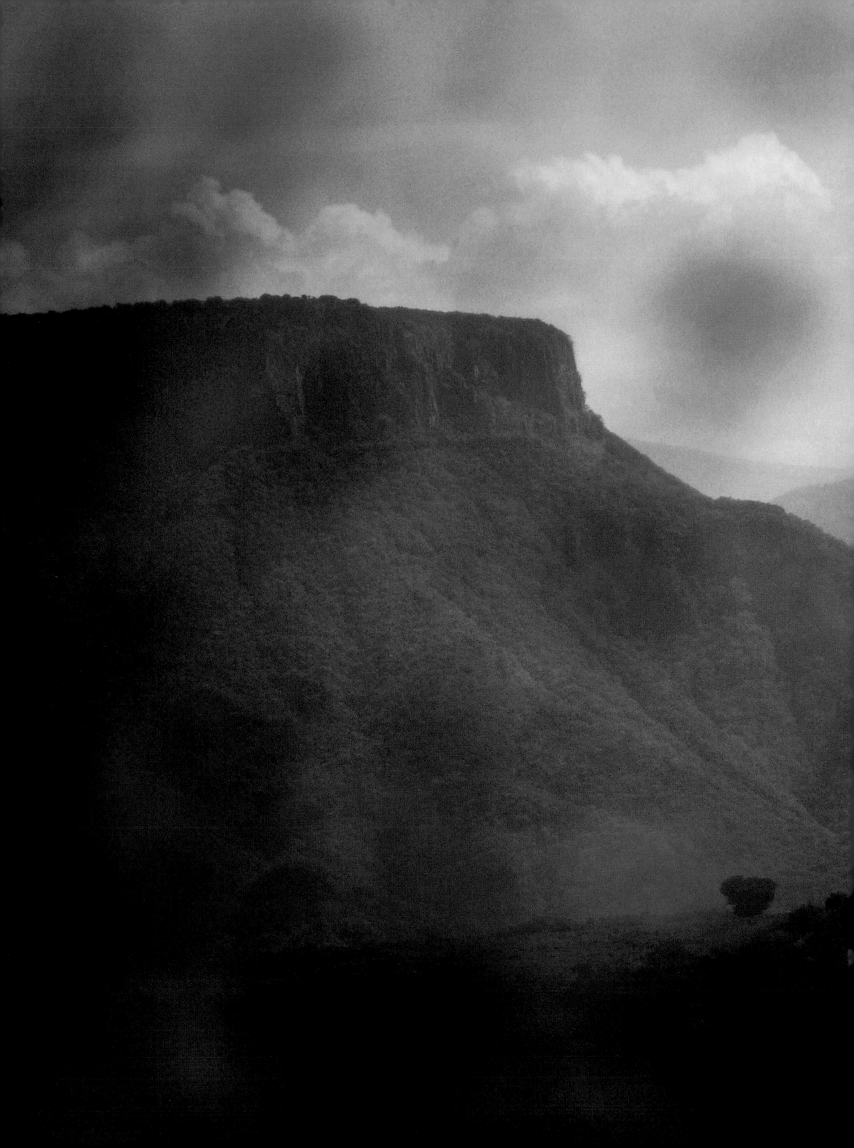

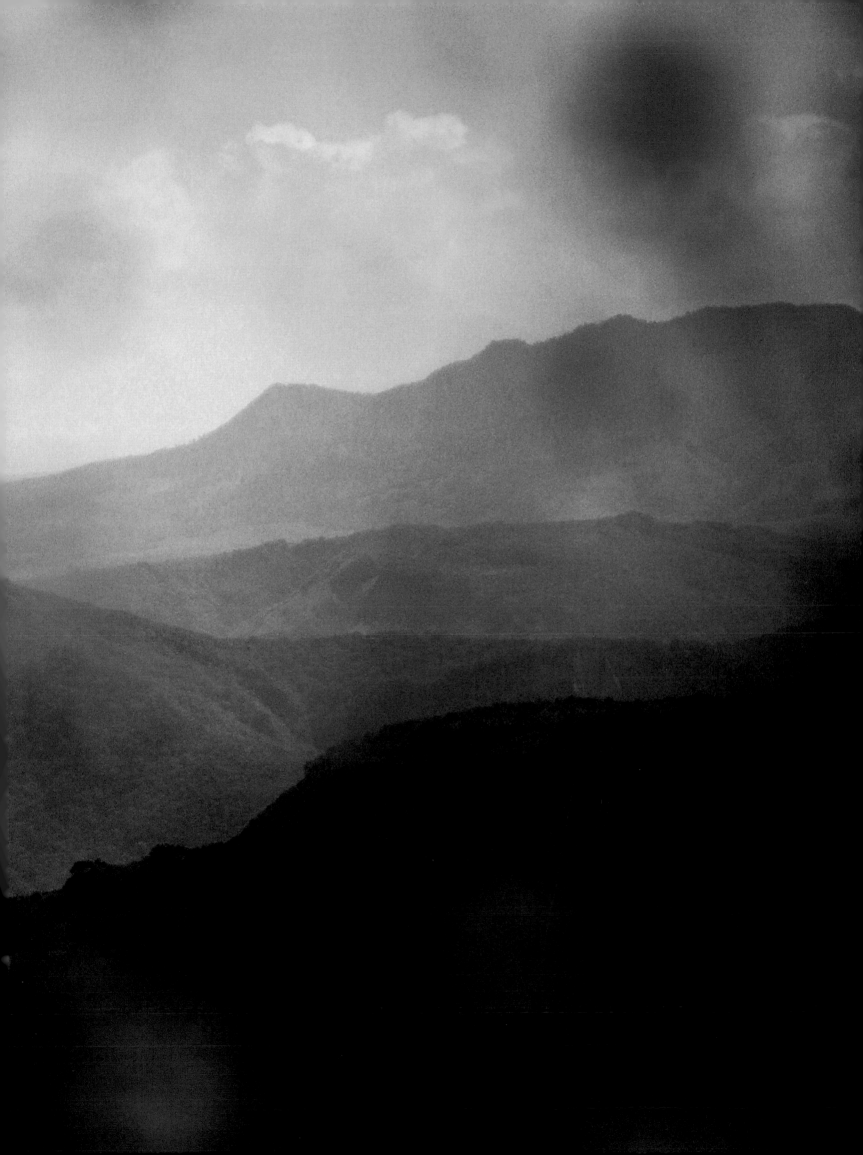

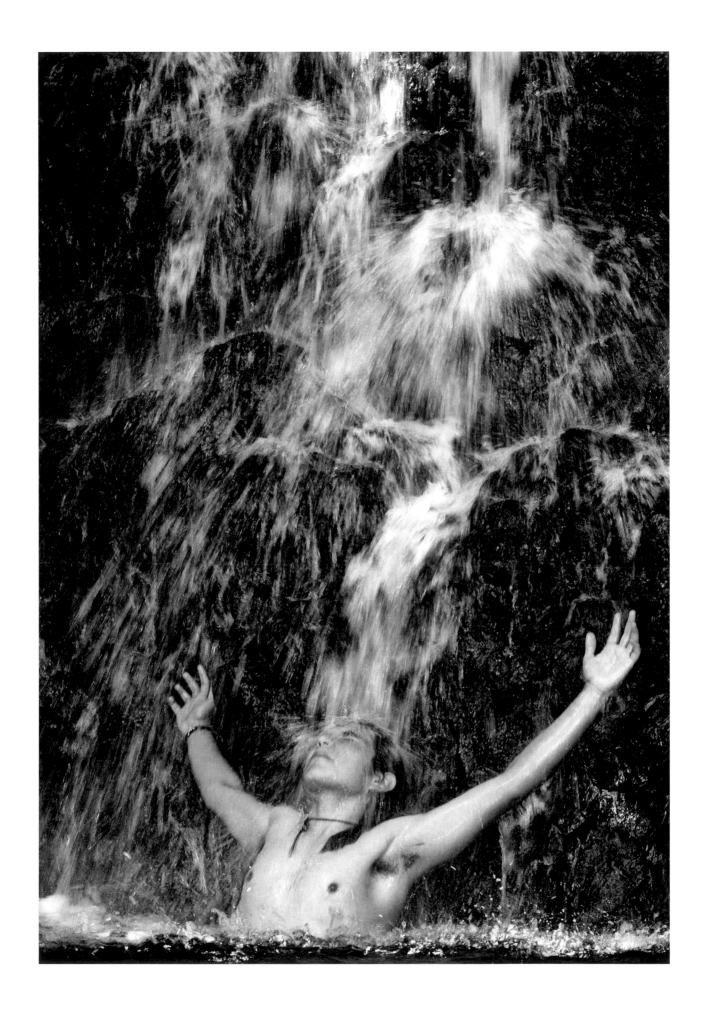

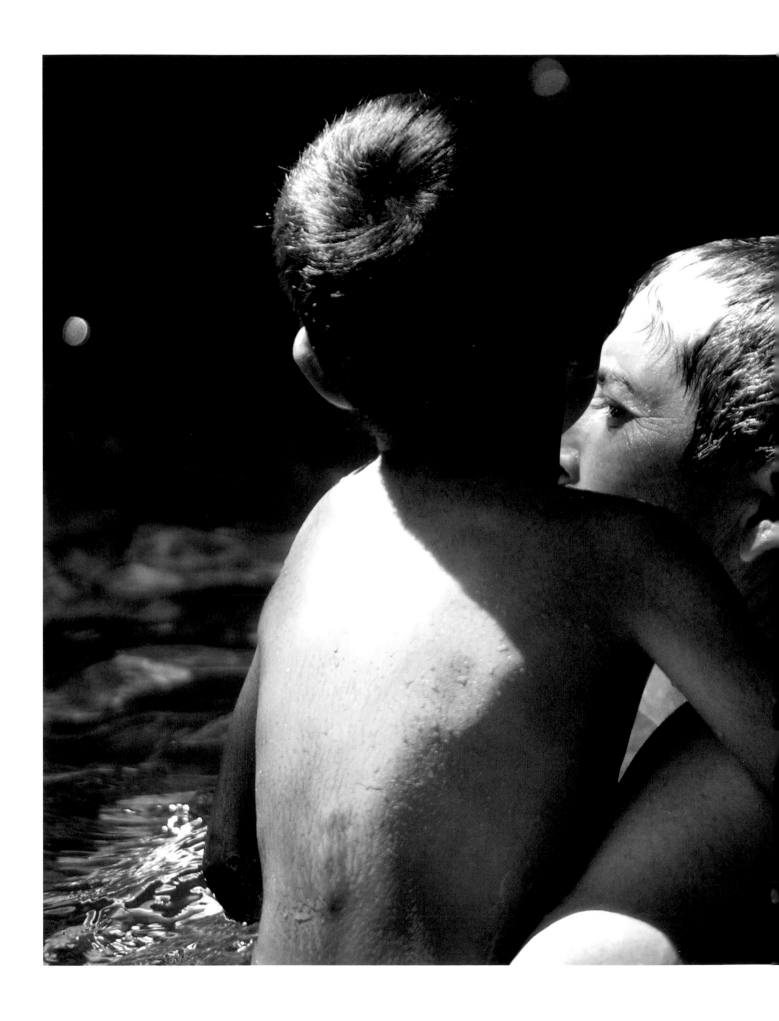

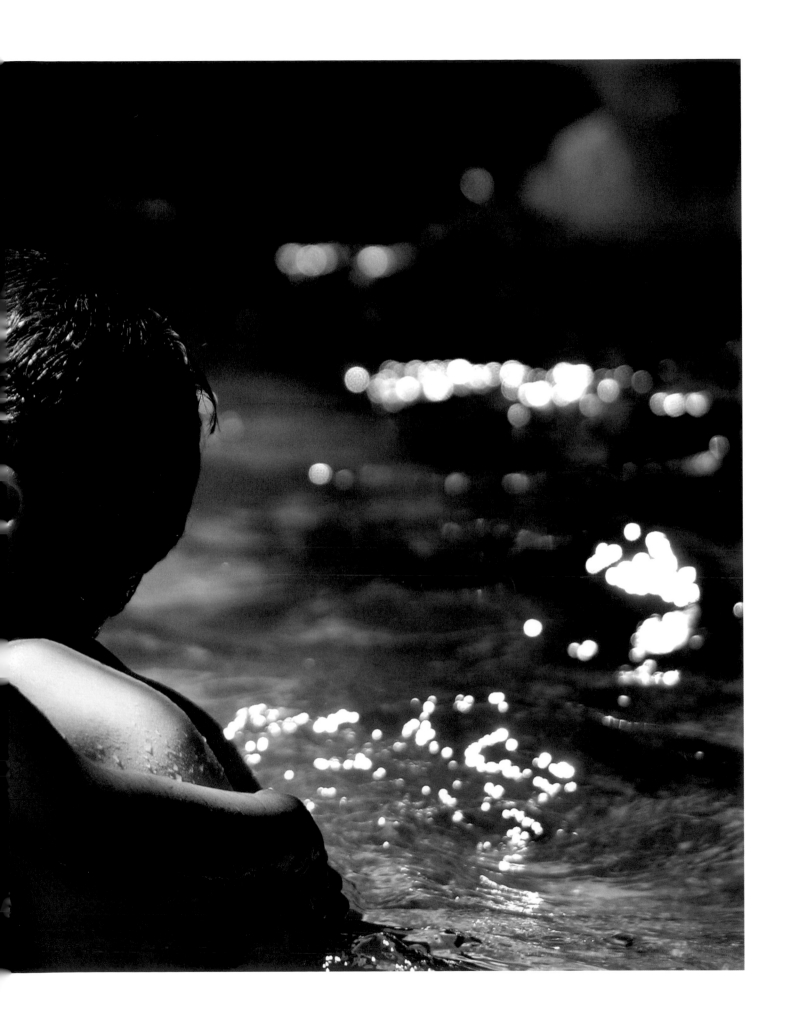

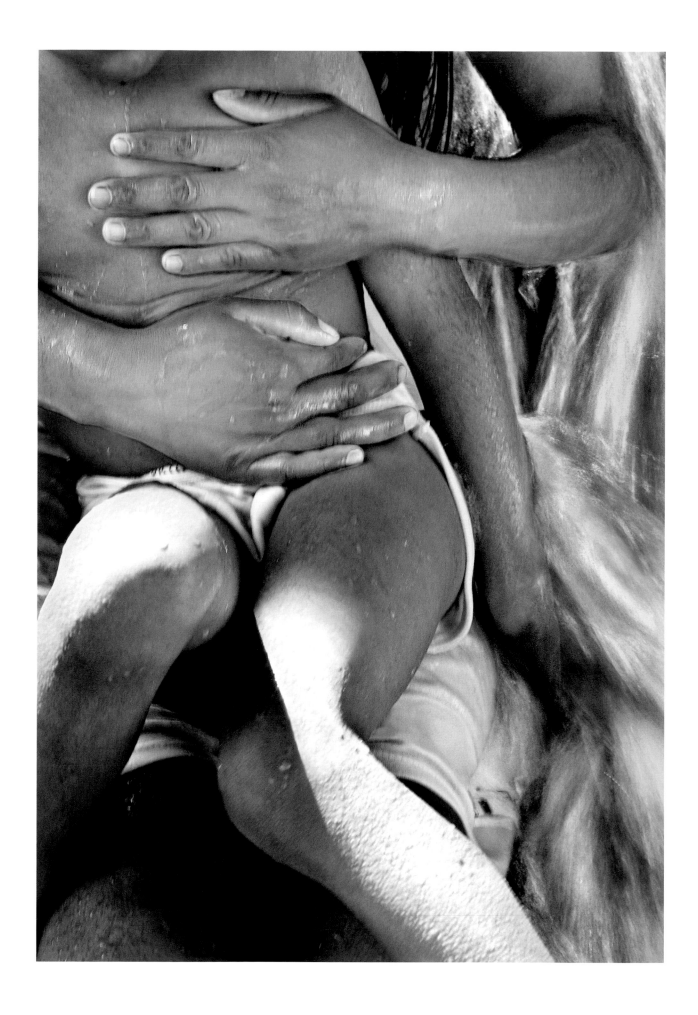

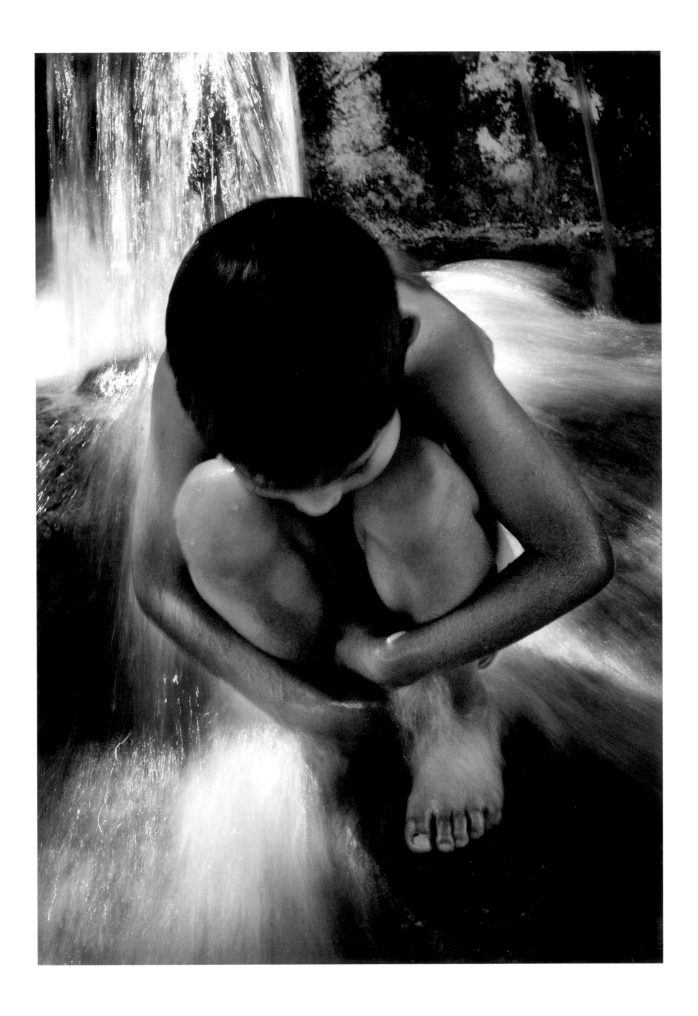

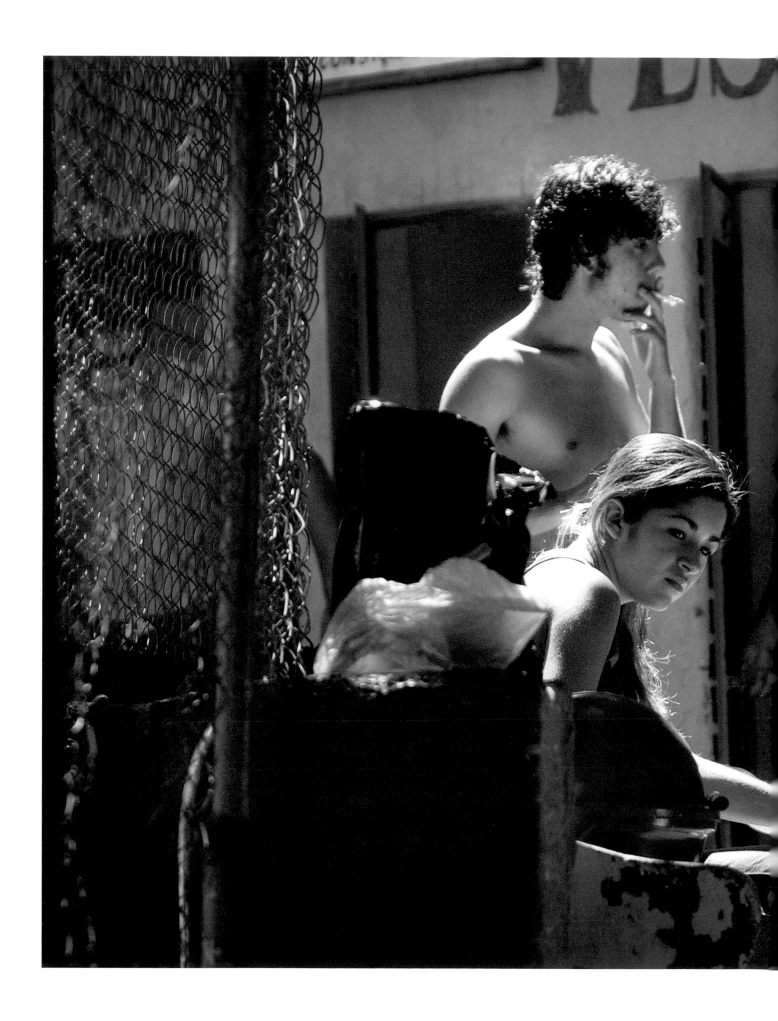

Just as the first scent and taste of tequila is silky smooth, almost sweet, so is the culture of Mexico in its first revelation to the outsider. Visitors are almost always treated with extreme courtesy and sincere warmth. Yet upon swallowing the tequila, its heat manifests itself, burning as it goes down; a reminder that below the serene surface of Mexico is a difficult reality driven by imbalances of power. An older woman surveying the landscape while sipping a tequila asks a visitor if they think her country is beautiful. She is sitting in a roadside park, a torrential waterfall rushing down behind her, and the expanse of the rugged green mountains of Los Altos de Jalisco stretches before her to the horizon. Her family is swimming in the pool beneath the waterfall. Not waiting for a reply, she begins to speak. "Although the land is indeed beautiful," she says, "most of our people are very poor, lacking education and opportunity." For many, she thinks this brings a fatalistic acceptance of the unfairness life can sometimes bring, but also tremendous tenacity and inner strength.

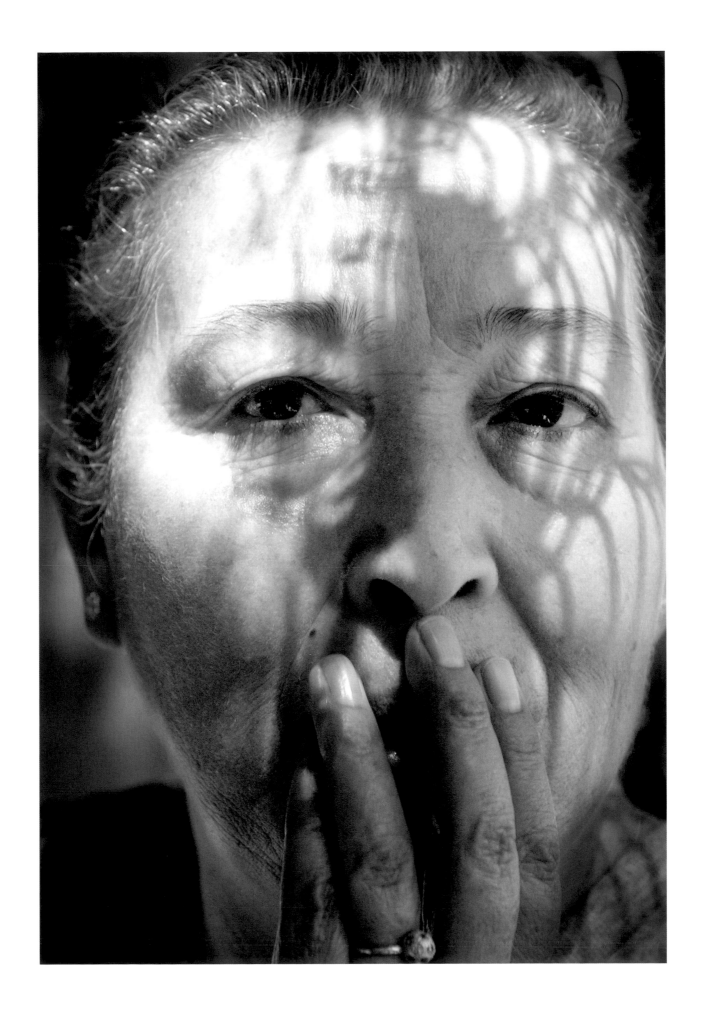

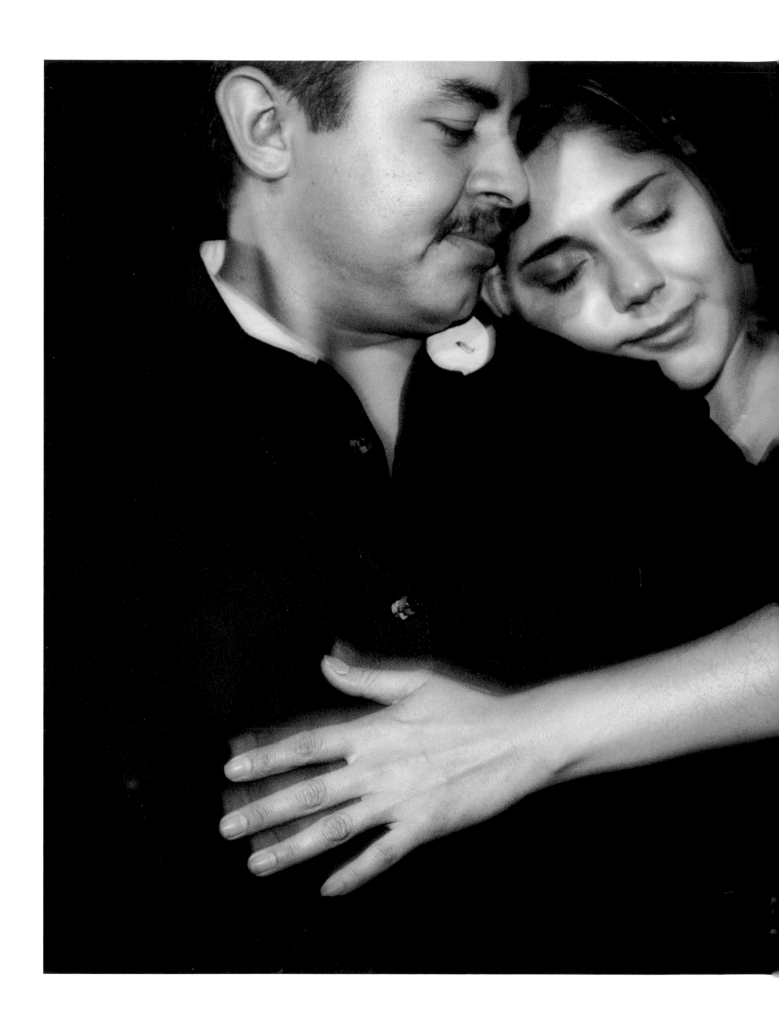

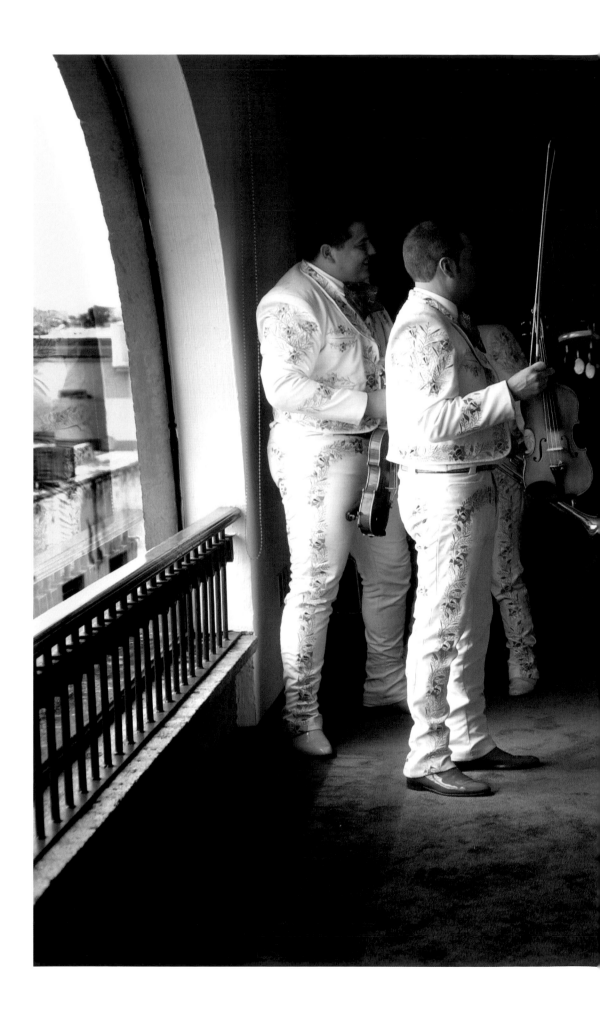

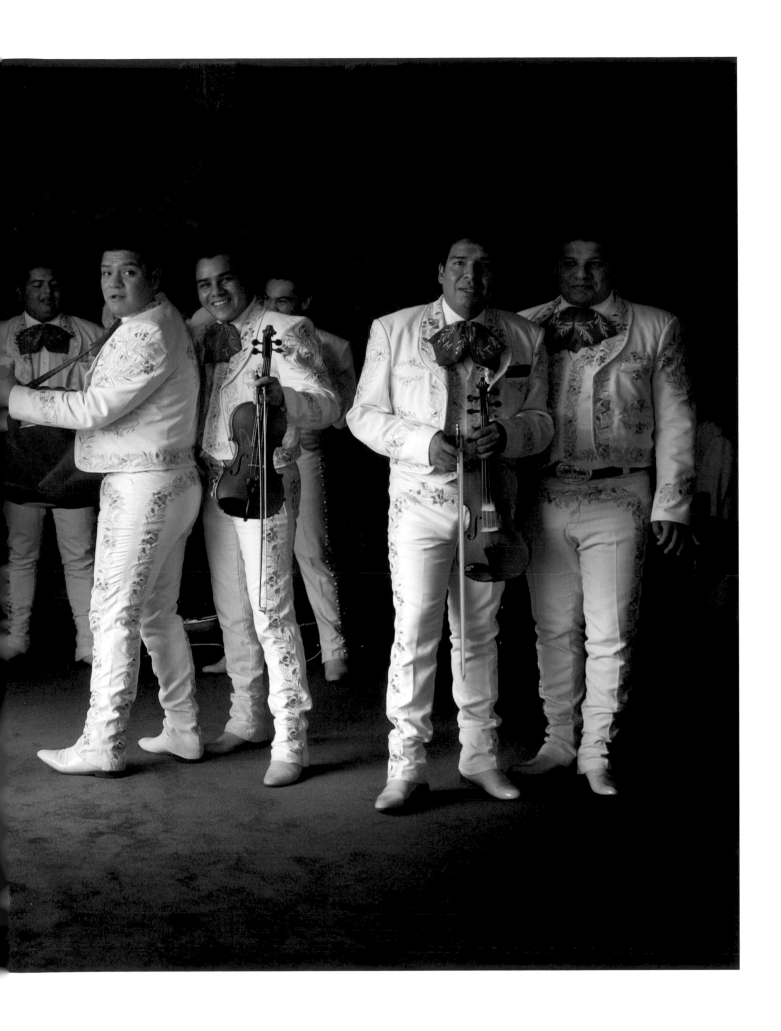

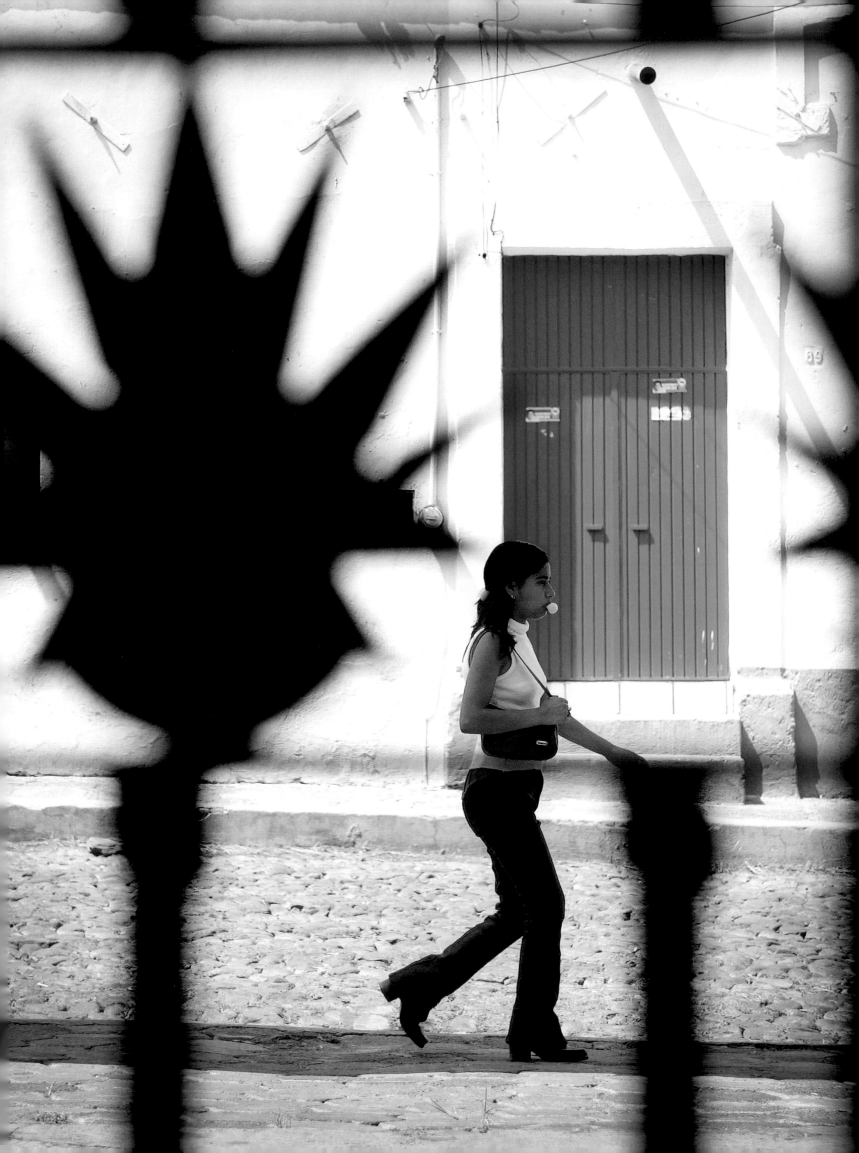

The bar is not really open this early in the afternoon. Except for one older man sitting in the corner alone, it is quiet and empty. Formerly a famous bullfighter hangout, El Bar Maestranza is where the local legends came to celebrate after historic fights. The best bulls' heads are stuffed, and hang ominously over the bar, their huge eyes permanently alert as if sensing the provocative matador. Soon, a group of young people arrive, trooping up the stairs, laughing and talking, calling friends on their cell phones. One of them places five bottles of blue agave tequila on the bar, all different types—a few blancos and reposadas with an añejo. He begins making friends as he lines them up on the bar. A woman grabs a knife from the bartender and begins to cut quarters of fresh limes, laying them out in rows. Little bowls of salt appear. The music is turned on and *Norteñas*, the mournful songs of Northern Mexico, fill the rooms. The empty bar is filling up and soon there is a party underway, everyone furiously smoking and drinking. After twenty minutes, the party is out of control, the five bottles are already empty and one of the young women is beginning to dance on the bar.

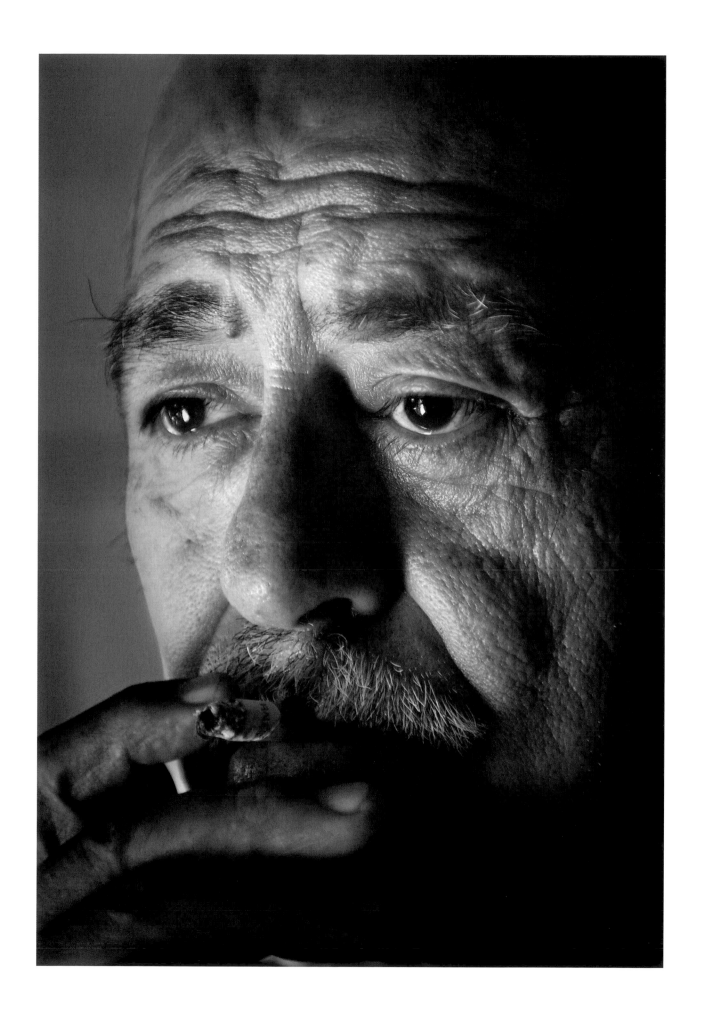

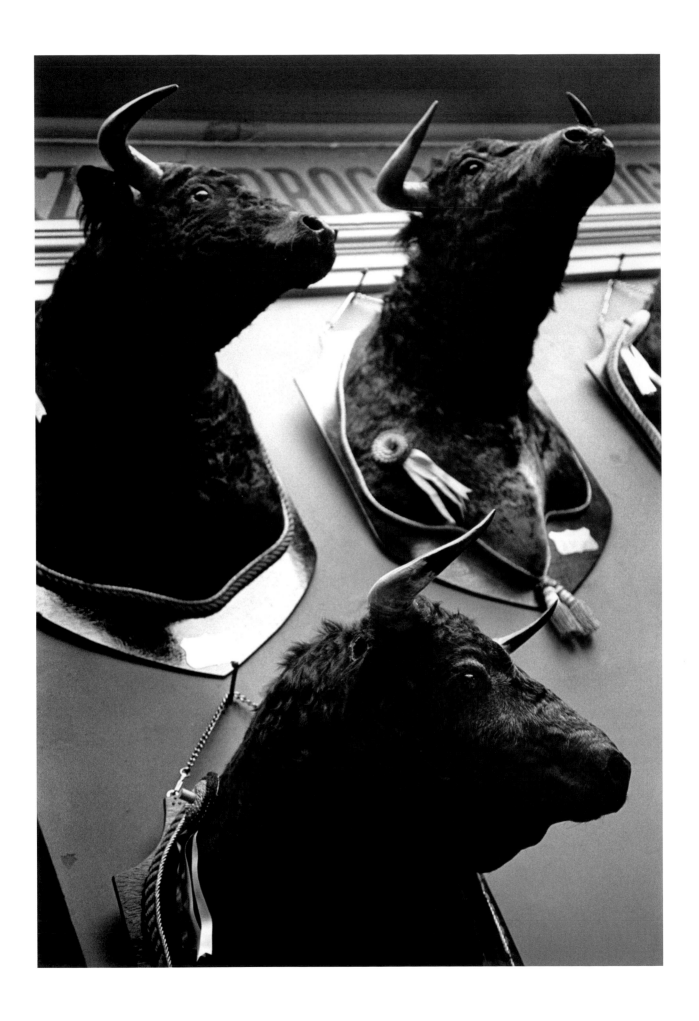

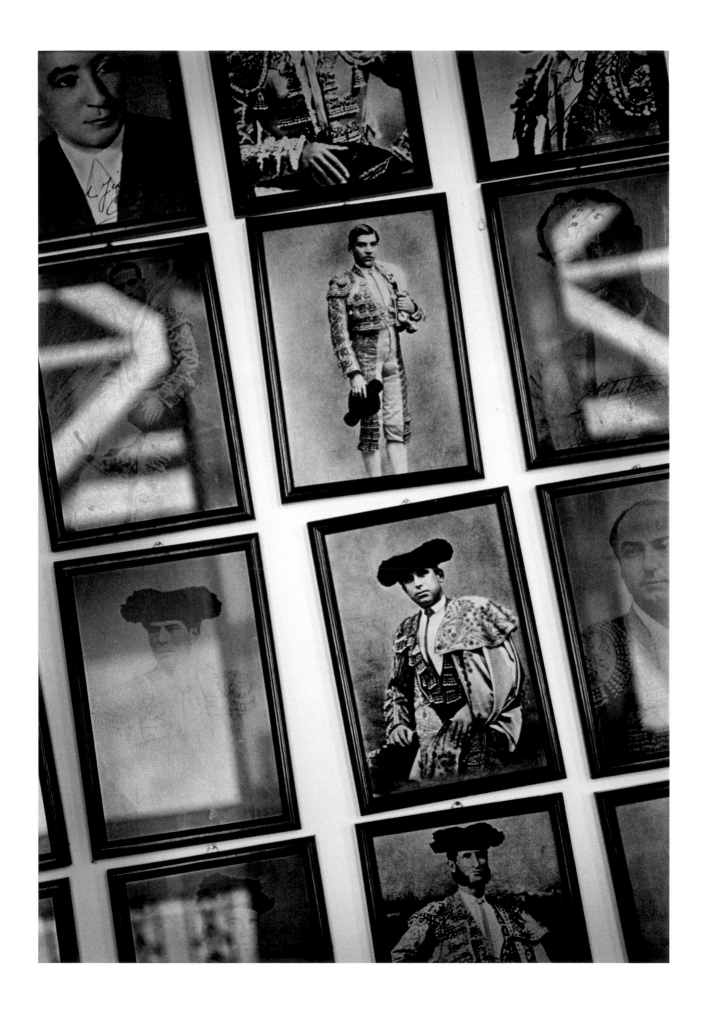

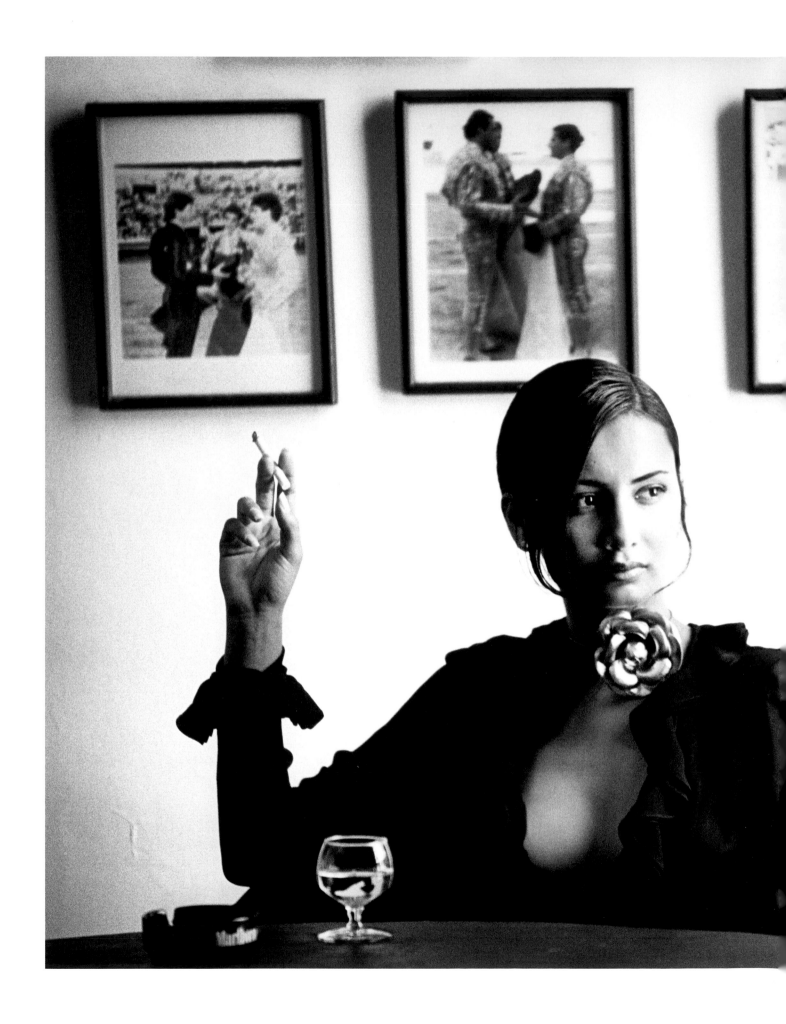

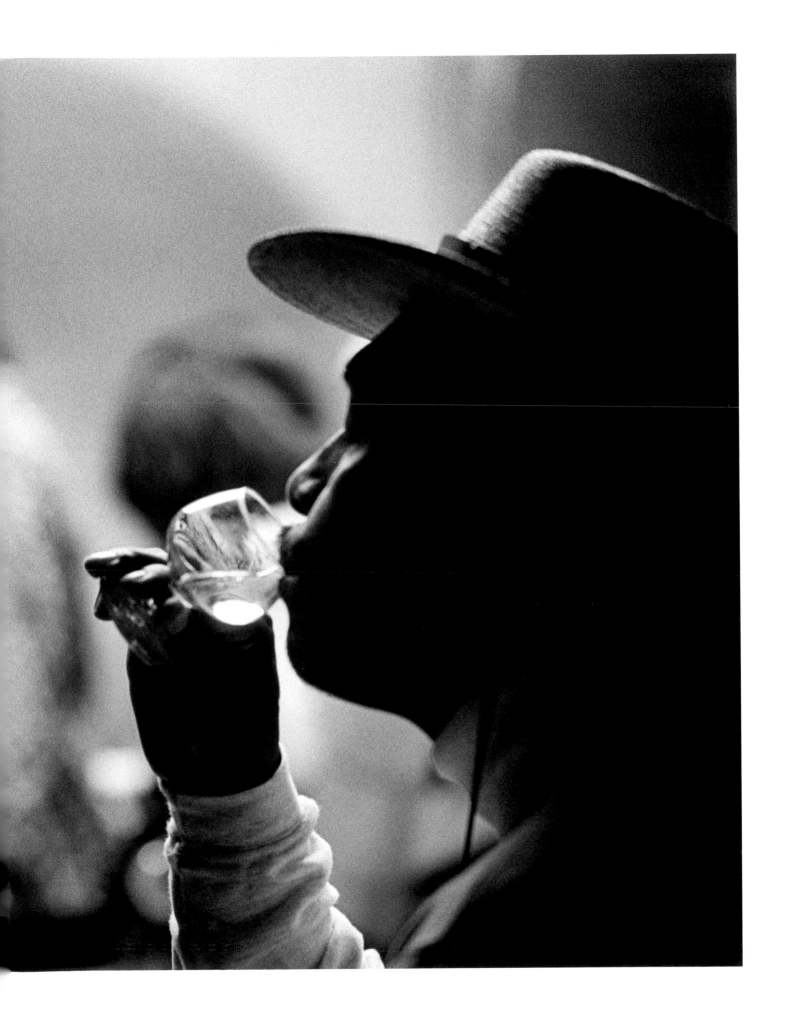

*"Es su compadre, su confesor, su cura.
El tequila es la única cosa de su vida."*

"It is your friend, your confessor, your cure. Tequila is the only thing in your life."

122

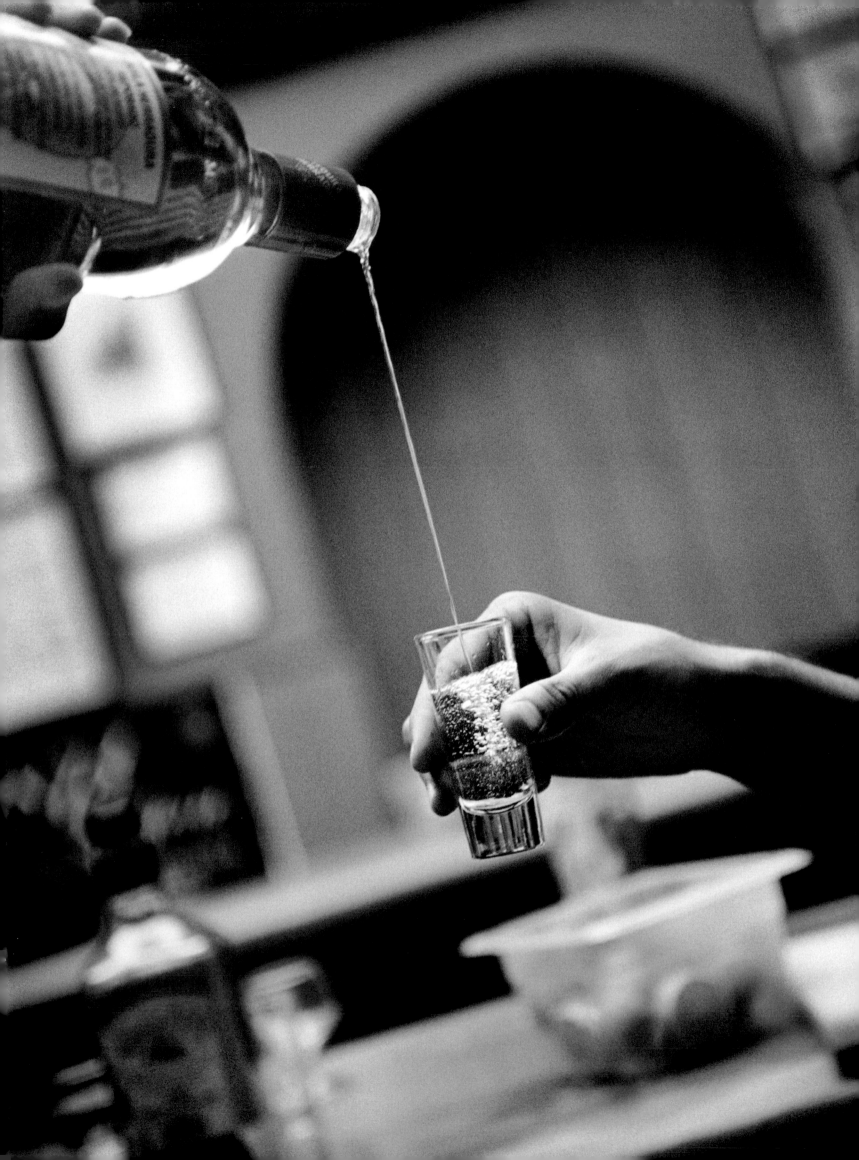

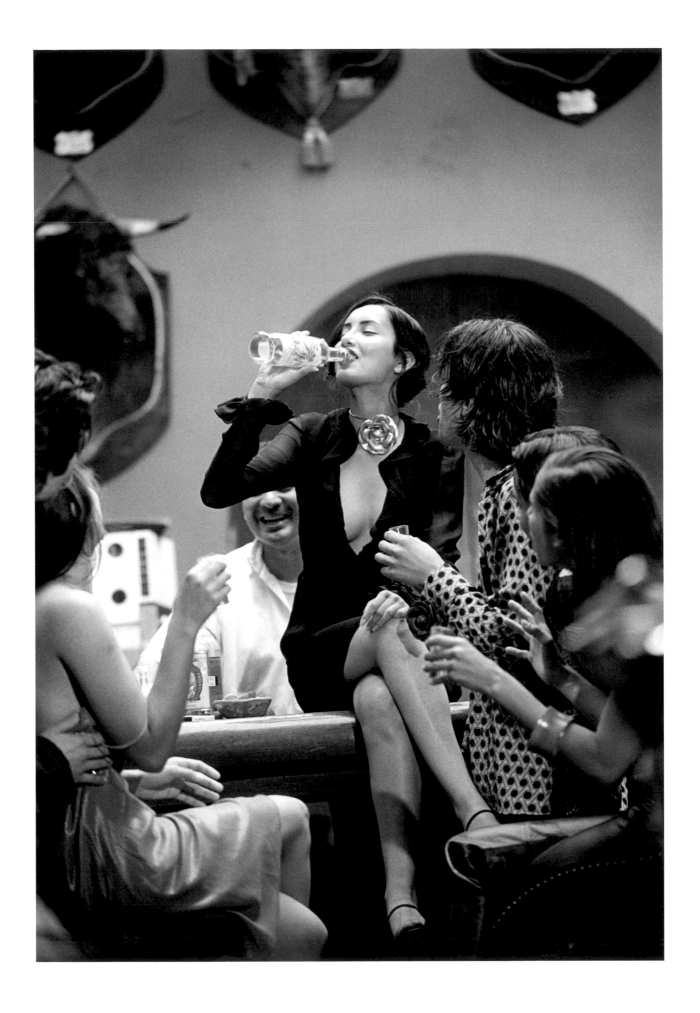

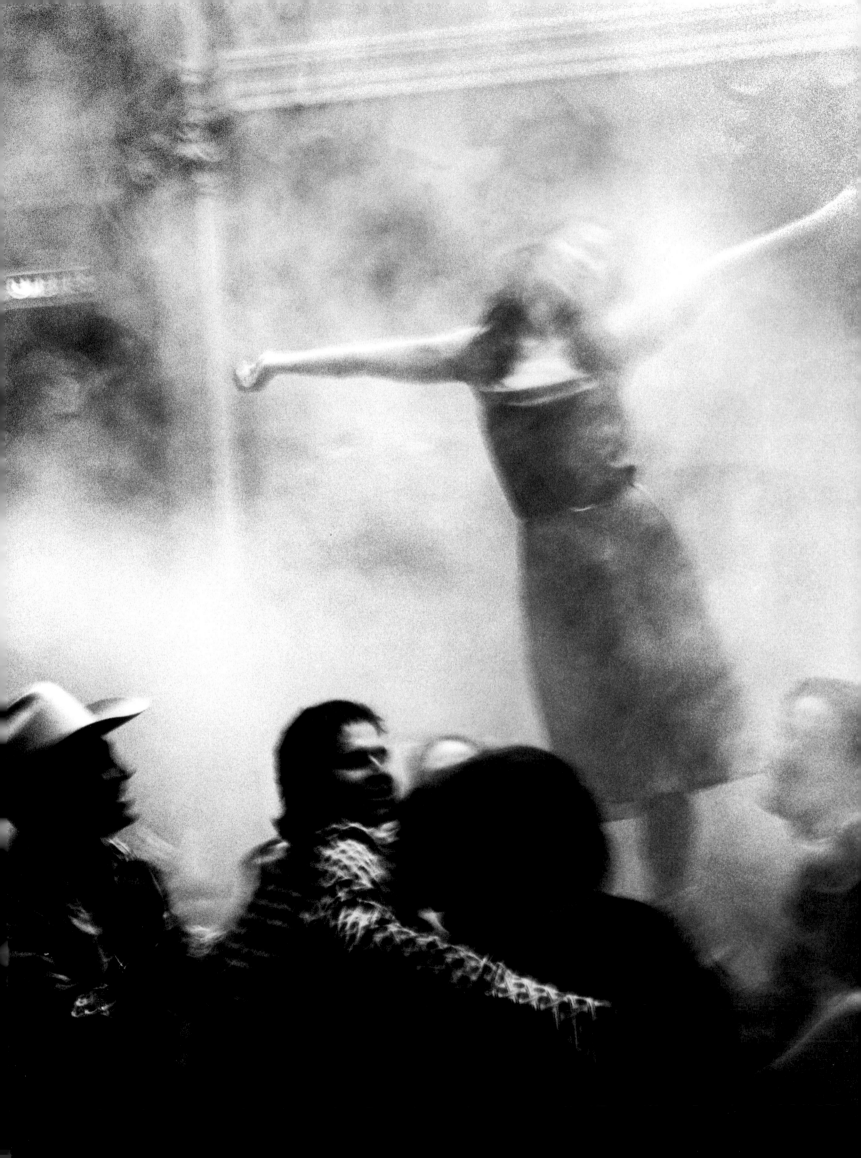

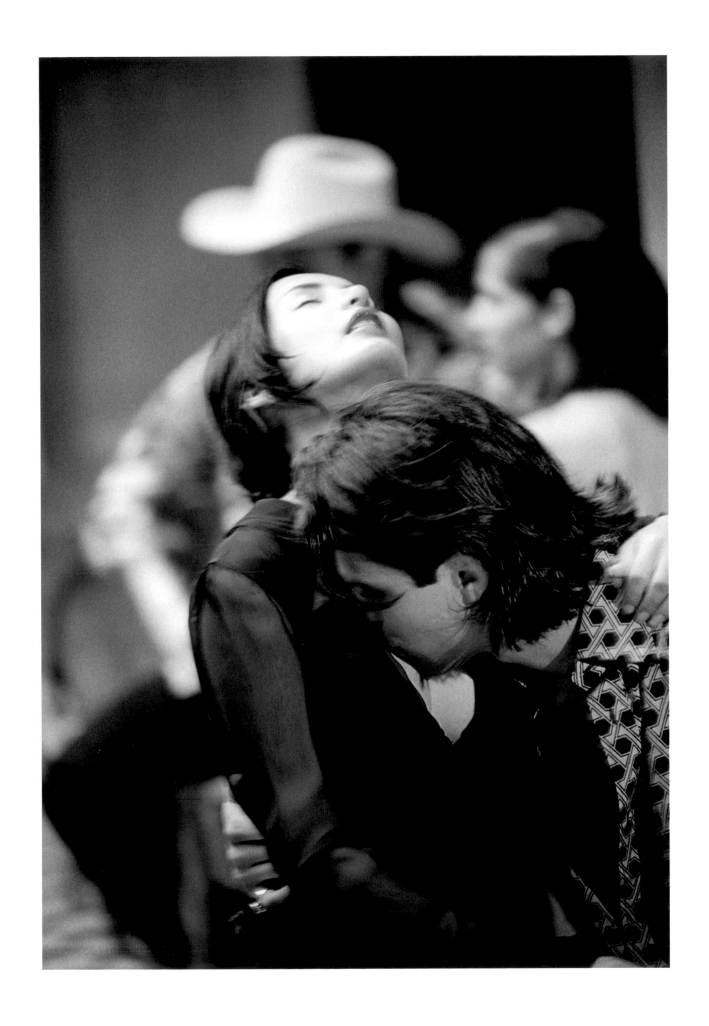

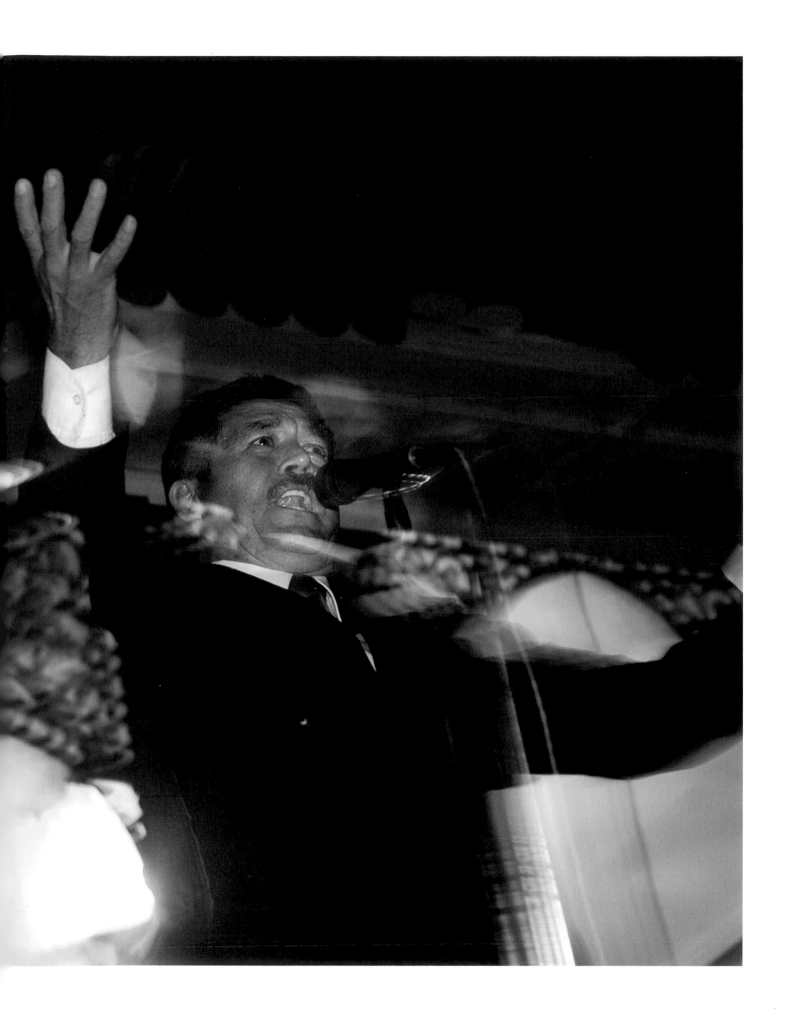

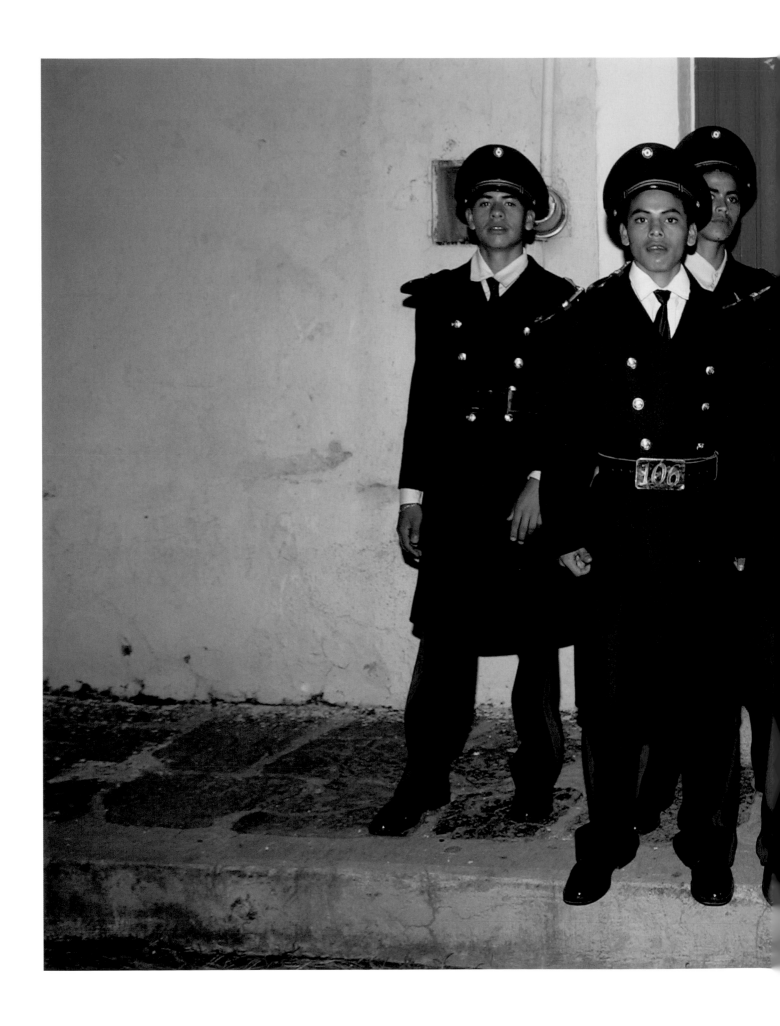

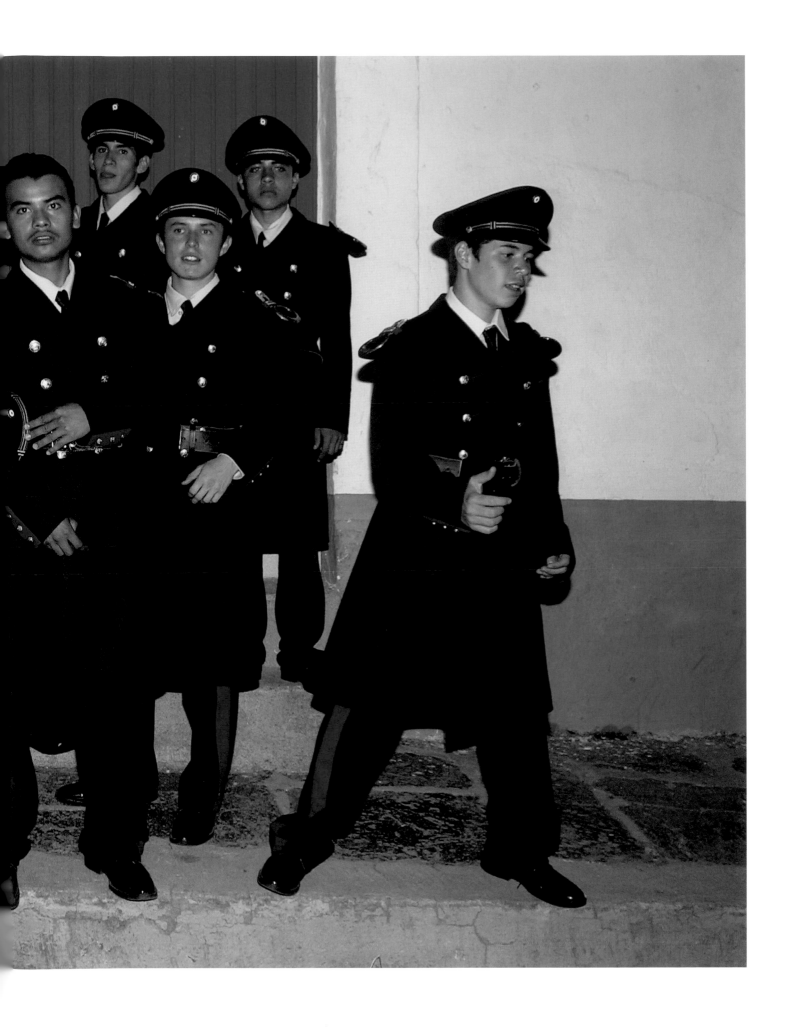

An hour before dawn on El Dia de la Virgen de Zapopan and the bars of Guadalajara have emptied into the streets. Drinkers, dancers, philosophers, lovers, and fighters—the whole town, young and old, is here today. Penitents on their knees are crawling the ten miles to the church. Some have blood on their hands and faces. Others are whipping themselves. People all around are praying fervently. Following behind are Indians—descendants of the Aztec, the Nahuatl, Olmecs, Mayans, Toltecs, and many others—living reminders of Mexico's huge indigenous population, mostly unseen by tourists in the main cities or beaches. These are the descedants of the people the Spaniards conquered, yet they are still here, dancing and singing in their original languages and costumes. The men from the agave fields are also here with their families, their one single day off in an entire year spent in devotion. Despite the symbolic violence of the penitents, the mood remains thankfully upbeat. The surging crowd is approaching rapture as the word passes that the Virgin is coming. Long ropes on either side are being passed up the avenue, a space is cleared in the center for the procession. Eventually the Virgin comes into view, dawn light slashing across a small, white, adorned statue atop a large, heavy box being carried by a dozen men. A woman close by blesses herself and begins to pray. The man with her does the same as thousands nearby follow suit. A woman, her face covered in blood, smiles blissfully as the crush of people eases a fraction. A skeleton death mask pauses, mildly threatening. The mask and its owner move on, following the Virgin.

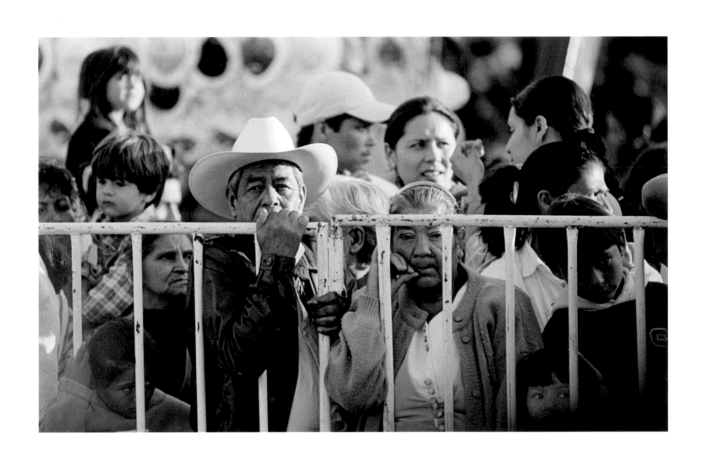

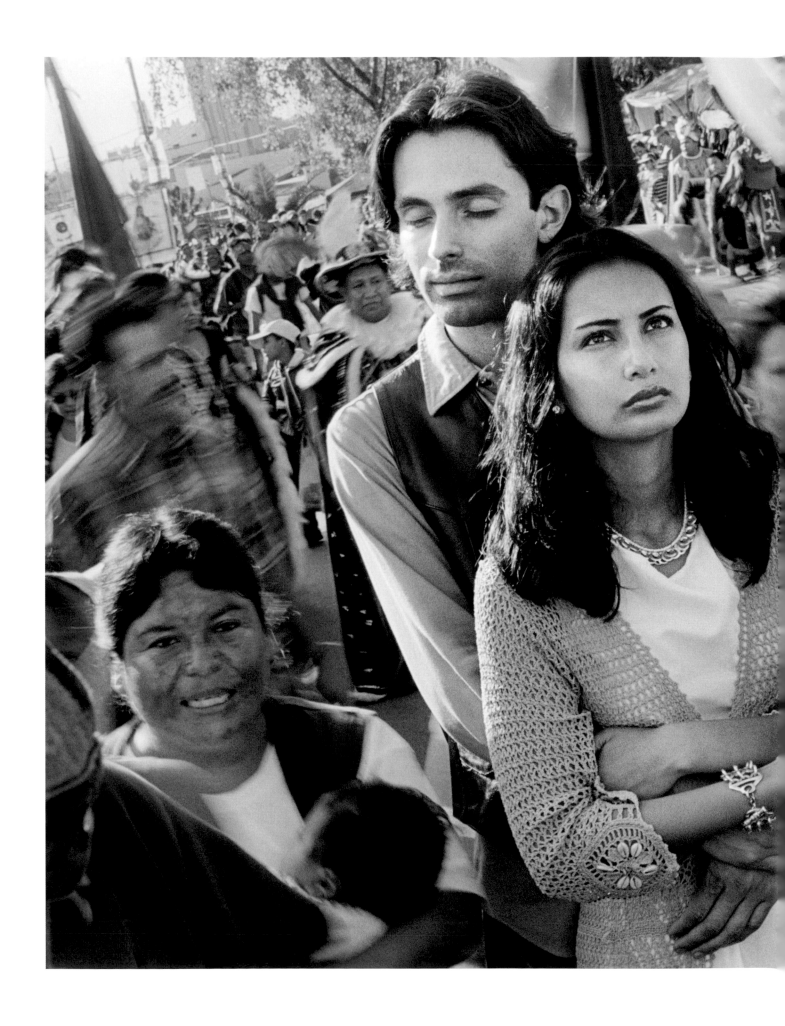

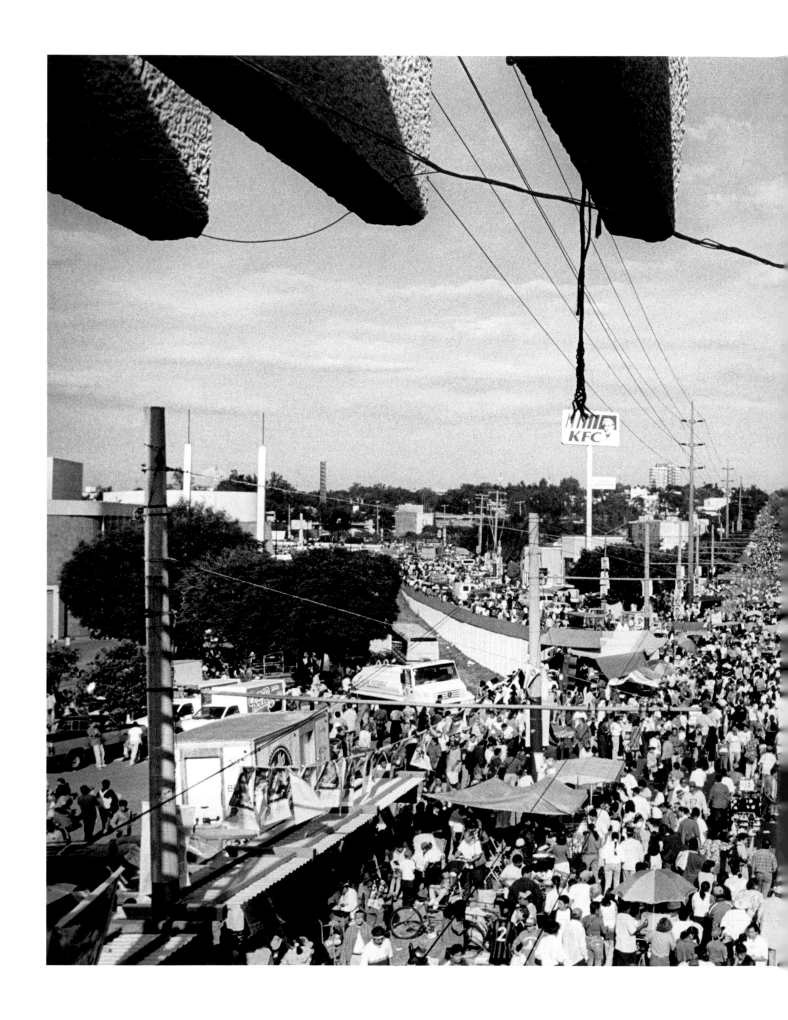

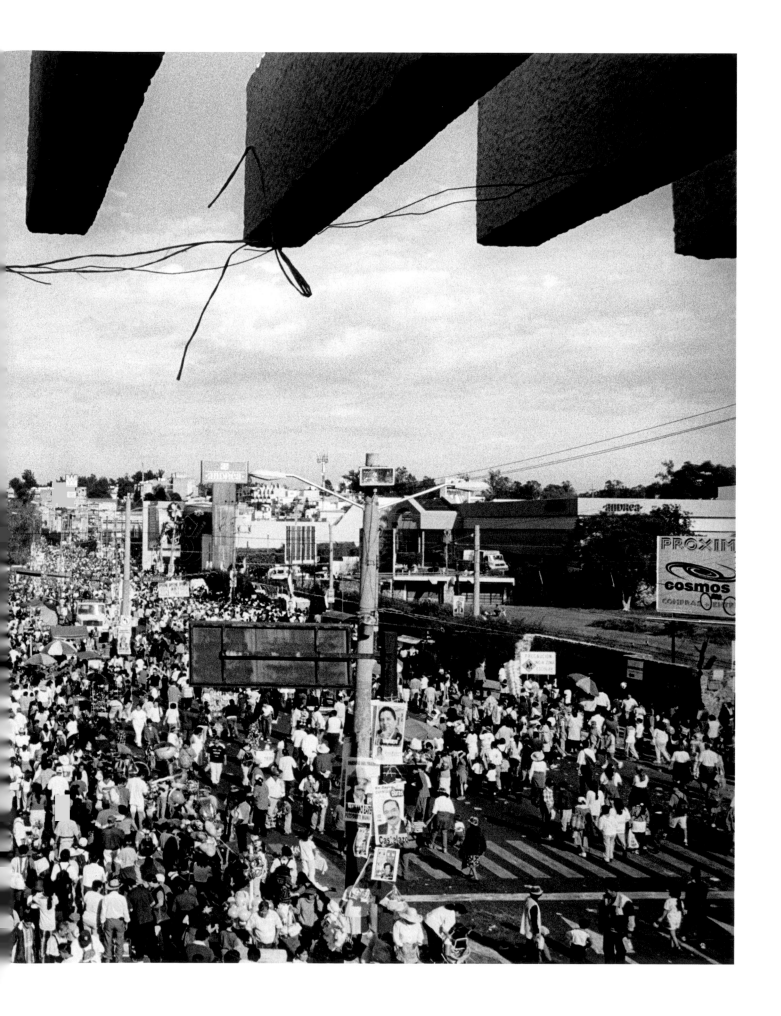

The light is fading. The smell of smoke and dust, the taste of tequila and the heat of the day are sense memories, printed on skin, hair, and clothes. Seeking the old ways of tequila has led to insights into the cauldron of forces shaping contemporary Mexican life. Every day is a clash of ancient, living history with the new economic and political realities. And this journey has brought forth much that visitors often miss of the true Mexico. Mostly, they miss the passion. Mexicans bring intense passion to everything they do. They experience life to the utmost—like the young bullfighter El Conde, or the old haciendado and his prized tequila—they are living and loving in the moment, with absolute faith in their destinies. Yes, life here is ritualized and guided by the strong need for respect and the exacting requirements of society. Whether breaking horses, getting married, or making tequila, there are traditions to follow. These traditions are rigorous and sacred and carried out in every social interaction, *passionately.* The heartbreaking beauty of these traditions provides comfort and purpose, which helps explain why they survive across generations of conquest, wars, and revolution. Through it all, tequila has been a constant, and is itself a product of tradition, ritual, and myth. Like a fist wrapped in velvet, tequila masks its elegant power. Thus, it is the perfect symbol and metaphor for Mexico, with its complexity and duality. The stranger may never really understand, but a small sip of tequila has been known to help enlighten even the most stubborn gringo.

¡Salud!

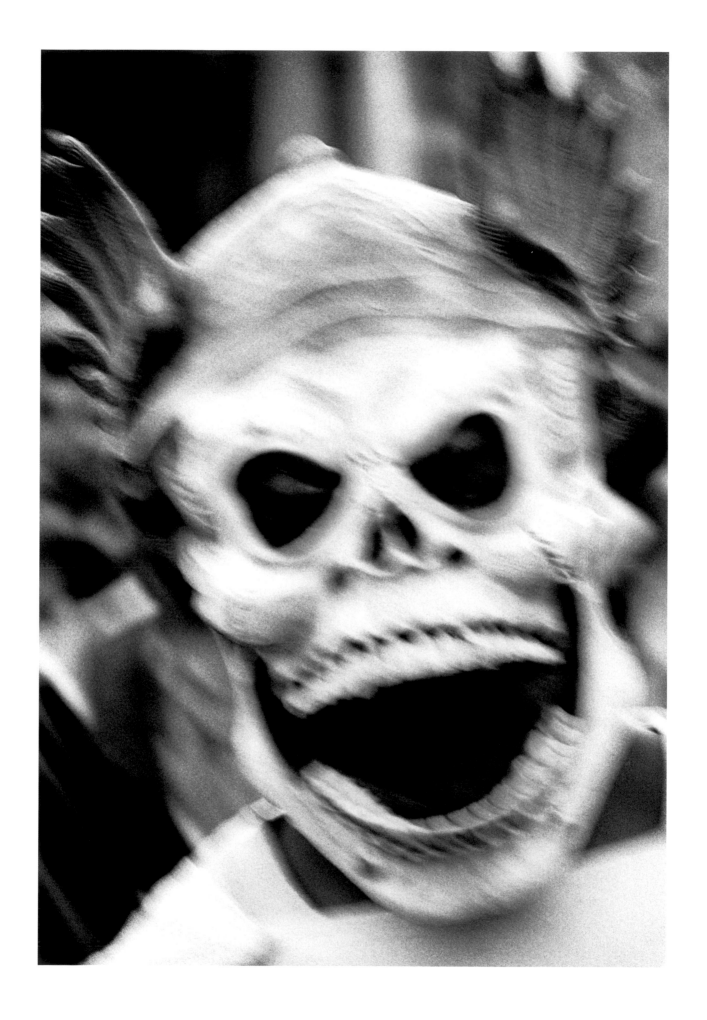

"It is the destiny of this heart to be cut, roasted, fermented and made an offering from Mexico to the world."

Afterword

In *Tequila: Panegyric and Emblem*, the Mexican poet Alvaro Mutis wrote:

Tequila has no history; there are no anecdotes confirming its birth. This is how it's been since the beginning of time, for tequila is a gift from the gods and they don't tend to offer fables when bestowing favors. That is the job of mortals, the children of panic and tradition.

Translated by Mark Schafer
From *Artes de México* magazine, issue 27

Despite its huge sales in the United States, tequila is still the most misunderstood and maligned liquor. Most people only know tequila through drunken encounters with low-quality tequila in their youth. To that end, I would like to impart some basic knowledge of Mexico's great spirit for those of you craving more.

The Source

Tequila is produced mostly in the western Mexican state of Jalisco, around the town of Tequila, about 34 miles west of the capital, Guadalajara. Many visitors know the state for its Pacific Coast resort town, Puerto Vallarta. Jalisco also has mining, manufacturing, arts, crafts, and jewelry industries.

Most of the tequila-producing communities in Mexico lie on an east-west line from Jésus Maria, through Guadalajara to Escobedo in the west. The two main areas of production lie around the town of Tequila, and in the highlands (Atotonilco, or Los Altos) to the east. The hills of the area are covered in agave farms sporting more than 100 million plants in spiky, gray-blue rows, 1,000 to 2,000 plants to an acre.

Today about 38,000 people work in the industry, about 33,000 of them farmers and field hands. More than 50 million gallons of tequila are produced annually—about forty percent of it exported. The indigenous people in the Tequila area were called the Nahuatl, and the town was founded under the Spanish commissioner Juan Calero de Escarcena, in April 1530, at the base of an extinct volcano. Tequila was made a municipality in 1824 and finally became a city in 1974. Today it has a population around 20,000.

Types of Tequila

1. *Blanco* or *plata* is white or silver. Aged less than sixty days in steel tanks, and may be bottled fresh from distillation. Sometimes this is more robust and peppery sharp than highly refined varieties, especially if it's 100 percent agave.

2. *Joven abocado* is young and smooth. Basically the same as blanco, but with coloring and flavoring ingredients added to make it look aged. These are also called *suave* or *oro* (gold) because of the coloring (usually from added caramel, almond, vanilla and sometimes oak essence). In the industry they're known as *mixto*, or mixed blends.

3. **Reposado means "rested."** Aged from two months to up to a year in oak casks or barrels. The tastes become richer and more complex. The longer the aging, the darker the color and the more the wood affects the flavor. Reposado accounts for more than sixty percent of all tequila sales in Mexico.

4. *Añejo* (aged) is vintage. Aged in government-sealed barrels of no more than 350 liters, for a minimum of a year, up to eight or ten years, although tequila doesn't age well beyond four or five years. It is usually removed from the barrels and racked into stainless steel tanks after four years. Many of the añejos become quite dark and the influence of the wood is more pronounced than in the reposado variety. After three or more years, añejos may be called *muy añejo* or *tres añejos* by the manufacturers. *Reserva de casa* usually means "premium," and may be a limited-production variety. Other unofficial categories include *gran reposado*—aged longer than the minimum—and *blanco suave*.

Types aside, all tequilas have similar alcohol contents—around thirty to forty percent (76 to 80 proof), similar to spirits such as Scotch or vodka. The most important identifier on the label, however, is "100% agave" or "100% agave azul"—*cien por ciento de agave*. This means it is made only from the blue agave plant. It was approved by a government inspector to ensure purity, and bottled in Mexico. If it doesn't say this, the alcohol can legally be made with up to forty-nine per cent from non-agave sugars—and still be called 'tequila.' Tequila made with less than 100 percent agave is called "mixto" but will not be labeled as such.

How to Drink Tequila

The traditional way to drink tequila is to use a tall, narrow shot glass called a *caballito* ("little horse") or *tequilito*, although most tequilas are perhaps better served in a brandy snifter so you can appreciate their aroma. The *caballito*, with its narrow base and wider mouth, is modeled after the original bull's horn, from which tequila was drunk. The bottom was cut flat so it could rest on a table.

Sip it straight, without the lime and the salt. Forget the margarita mix. Don't even add ice. If you want to taste it properly, drink it at room temperature to appreciate the full bouquet and body. Taste it as you would a fine wine—life is really too short to miss out on enjoying it properly.

What Makes a Good Tequila

What makes a good tequila? For some it is the earthy, vegetable taste and aroma of the agave. For others it is the sharp bite of the blanco or reposado. Still others prefer the smooth, oaky body of the añejos. Edgar Allen Poe's three commandments for great writing—brevity, intensity and effect—capture the essence of a good tequila.

The best advice is to try several brands and several types to find the taste you like. Some distilleries have reputations for making mild, spicy or earthy brands, others for a strong alcohol finish or other tastes. A good way to introduce yourself to tequila is to find a bar that specializes in it, and a bartender who understands the differences between the various types, or attend a tequila tasting.

Common Myths About Tequila

Myth 1: The worm. There is no worm in Mexican-bottled tequila and it is not a Mexican tradition. There never has been a worm in tequila. There is a "worm"—a *gusano*, really a butterfly caterpillar— in some bottles of mezcal, but not all. You may also get a small bag of "worm salt"— dried gusano, salt, and chili powder tied to a mezcal bottle.

Myth 2: Tequila is made from cactus. Tequila is made from distilled sap from the hearts (piñas) of the mature agave or maguey plant. This plant is a succulent (not a cactus) related to the lily and amaryllis.

Myth 3: Tequila and mezcal are the same. Tequila is a type of mezcal, but mezcals are not tequilas. They both derive from varieties of the agave plant, but tequila is made from only *Agave tequilana Weber*, or blue agave. Despite many similarities, tequila and mezcal are as different today as Scotch whisky and rye. Most commercial mezcal is produced in Oaxaca state, while most tequila is made in or near Jalisco. Production processes are also very different—obvious in their resulting tastes.

Myth 4: Tequila is bottled home-brew. Production is tightly controlled by the Mexican government and the Tequila Regulatory Council (CRT). Statements made on the bottle about age, style and content have legal requirements. There is also a non-profit council called the Chamber of Tequila Producers that regulates the industry. Most manufacturers take considerable pride in their production.

Myth 5: The best tequilas cost the most. Price isn't always a good way to judge the value of things. A lot of the cost may go to fancy packaging, designer bottles, large advertising campaigns and simply to status and image. There's a large market of excellent mid-priced tequilas available in Mexico. However, as a general rule, premium and 100 percent agave tequilas cost much more than mixtos.

Myth 6: All tequilas are the same. Tequilas vary considerably according to the company making them, the processes, and the growing environment. The temperature, soil, types of equipment, age of the plants, how the plants are baked and how the distilled tequila is aged all affect the flavor, color, and body. There is a surprisingly wide variation in tequila flavors—especially between styles like blanco, reposado and añejo—and even more between 100 percent agave and mixto tequilas.

Finally, when drinking tequila, remember to explore, enjoy, and sip in good health!

Additional Reading

A New Time for Mexico, by Carlos Fuentes, University of California Press (1997)

Distant Neighbors: A Portrait of the Mexicans, by Alan Riding, Vintage; (1989)

The Labyrinth of Solitude and Other Writings, by Octavio Paz, Grove Press (1985)

Mexico: Biography of Power, by Enrique Krauze, Perennial (1998)

The Mexico Reader: History, Culture, Politics (The Latin America Readers), by G. M. Joseph, Duke University Press (2003)

Opening Mexico: The Making of a Democracy, by Julia Preston and Samuel Dillon, Farrar, Straus and Giroux (2004)

The Oxford History of Mexico. by Michael C. Meyer, Oxford University Press (2000)

Tequila: A Natural and Cultural History, by Ana Guadalupe Valenzuela-Zapata and Gary Paul Nabhan and Ana Guadalupe Valenzuela Zapata, University of Arizona Press (2004)

Tequila: A Traditional Art of Mexico, by Alberto Ruy Sanchez, and Margarita de Orellana (Editors), Smithsonian Books (2004)

For additional information about tequila go to www.ianchadwick.com

To purchase photographs from this book or to see other work
by Douglas Menuez go to www.menuez.com

Douglas Menuez is represented by @radical.media
www.radicalmedia.com